Contemporary Expressions

COLORING BOOK FOR ADULTS BASED ON ABSTRACT EXPRESSIONISM

Ken O'Toole

Irish Lion Media

FORT WORTH, TEXAS

Copyright © 2016 by Ken O'Toole.

All rights reserved. No part of this publication may be reproduced, distributed or transmitted in any form or by any means, including photocopying, recording, or other electronic or mechanical methods, without the prior written permission of the publisher, except in the case of brief quotations embodied in critical reviews and certain other noncommercial uses permitted by copyright law. For permission requests, write to the publisher, addressed "Attention: Permissions Coordinator," at the address below.

S.K. O'Toole/Irish Lion Media

6624 Monterrey Dr.

Fort Worth, Texas/76112

www.irishlionmedia.com

Ordering Information:

Quantity sales. Special discounts are available on quantity purchases by corporations, associations, and others. For details, contact the "Special Sales Department" at the address above.

Contemporary Expressions: Coloring Book for Adults Based on Abstract Expressionism/ Ken O'Toole. —1st ed.

ISBN-13: 978-1523258338

ISBN-10: 1523258330

Dedicated to All Artists

"The artist is nothing without the gift, but the gift is nothing without work."

Emile Zola

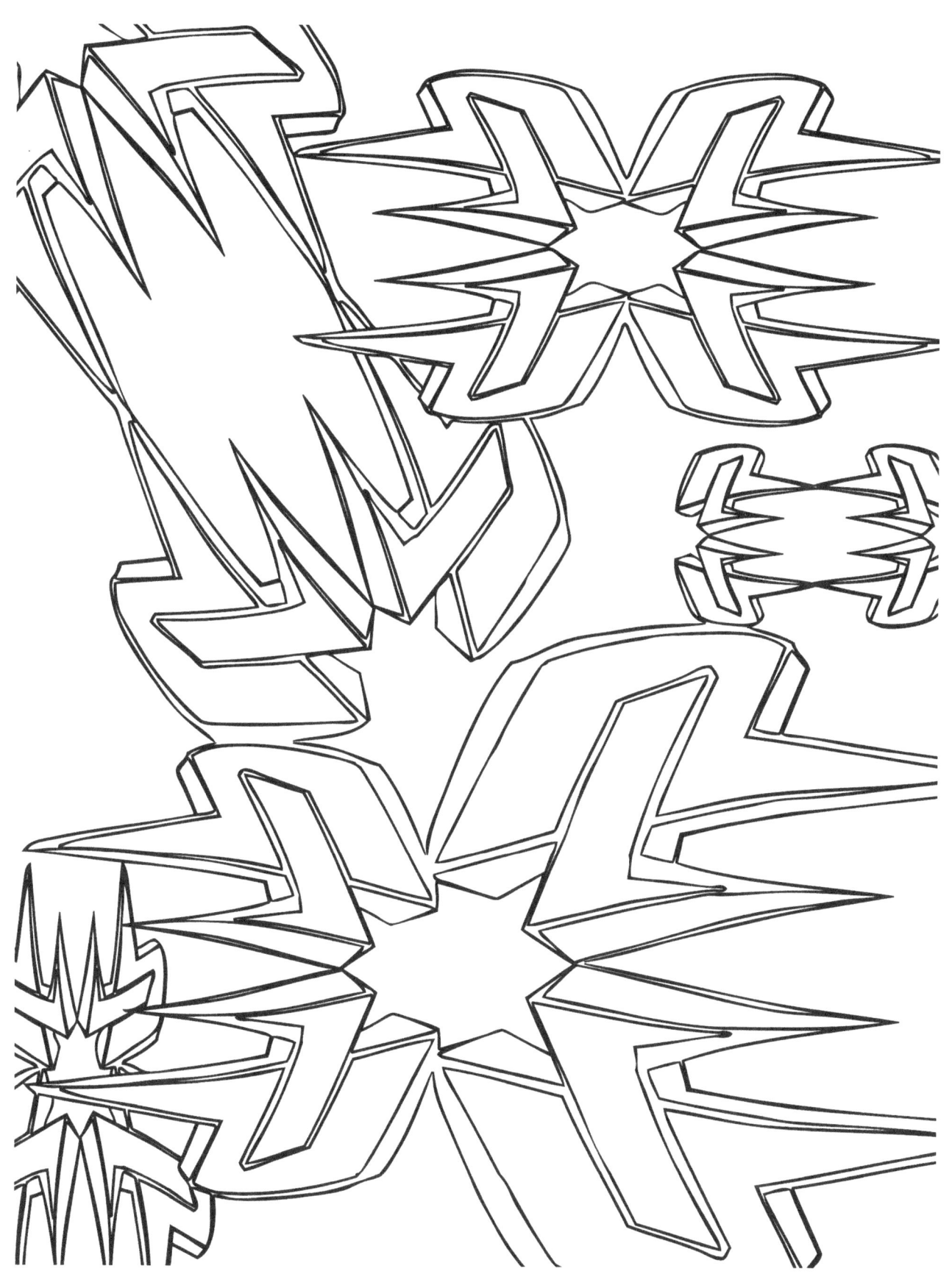

"Deliver me from writers who say the way they live doesn't matter.
I'm not sure a bad person can write a good book.
If art doesn't make us better, then what on earth is it for."

Alice Walker

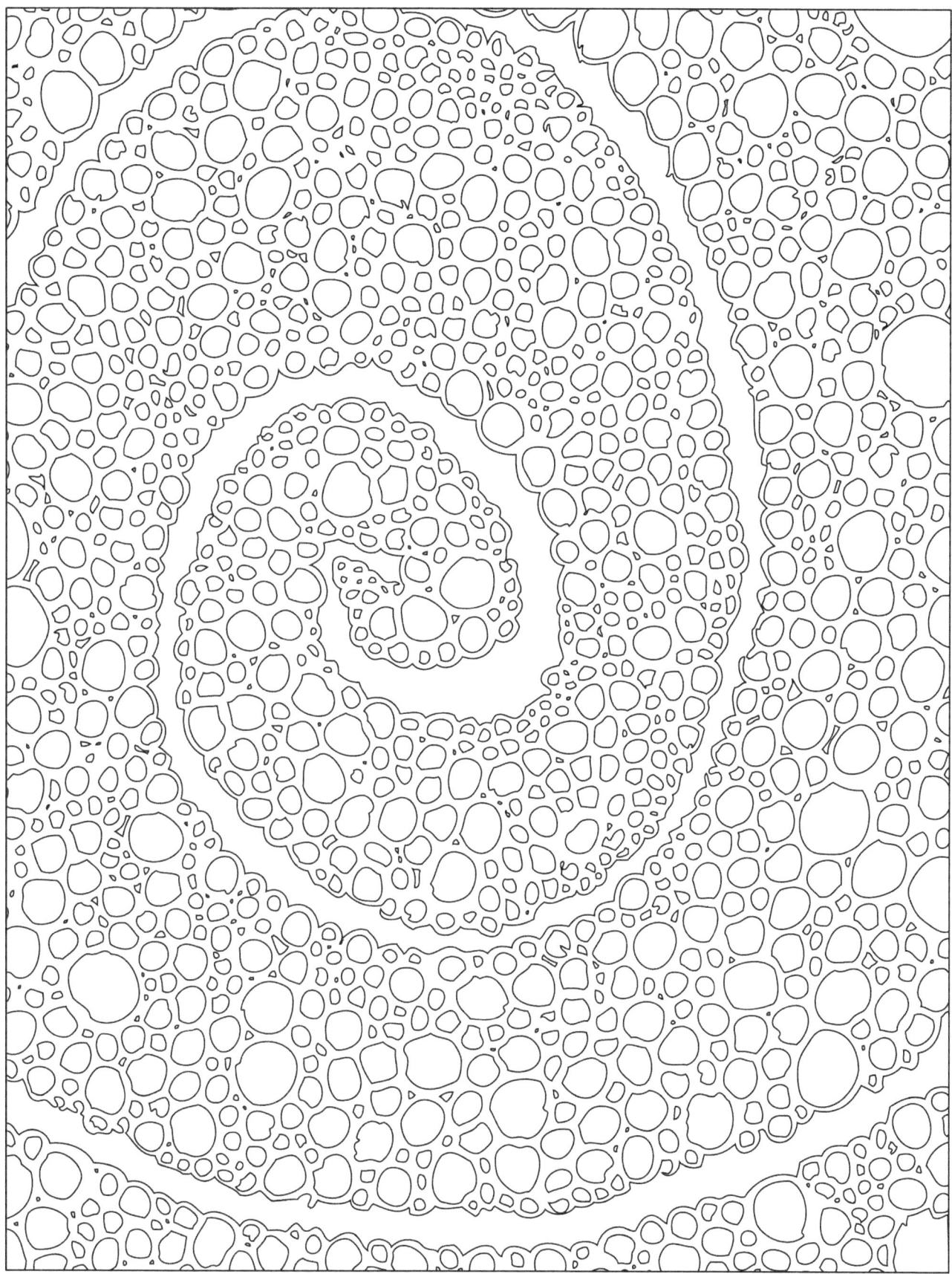

"A painter should begin every canvas with a wash of black, because all things in nature are dark except where exposed by the light."

Leonardo da Vinci

"Creativity takes courage."

Henri Matisse

"The most beautiful experience we can have is the mysterious - the fundamental emotion which stands at the cradle of true art and true science."

Albert Einstein

"Art is not what you see, but what you make others see."

Edgar Degas

"If being an egomaniac means I believe in
what I do and in my art or music, then in that respect
you can call me that...I believe in what I do, and I'll say it."

John Lennon

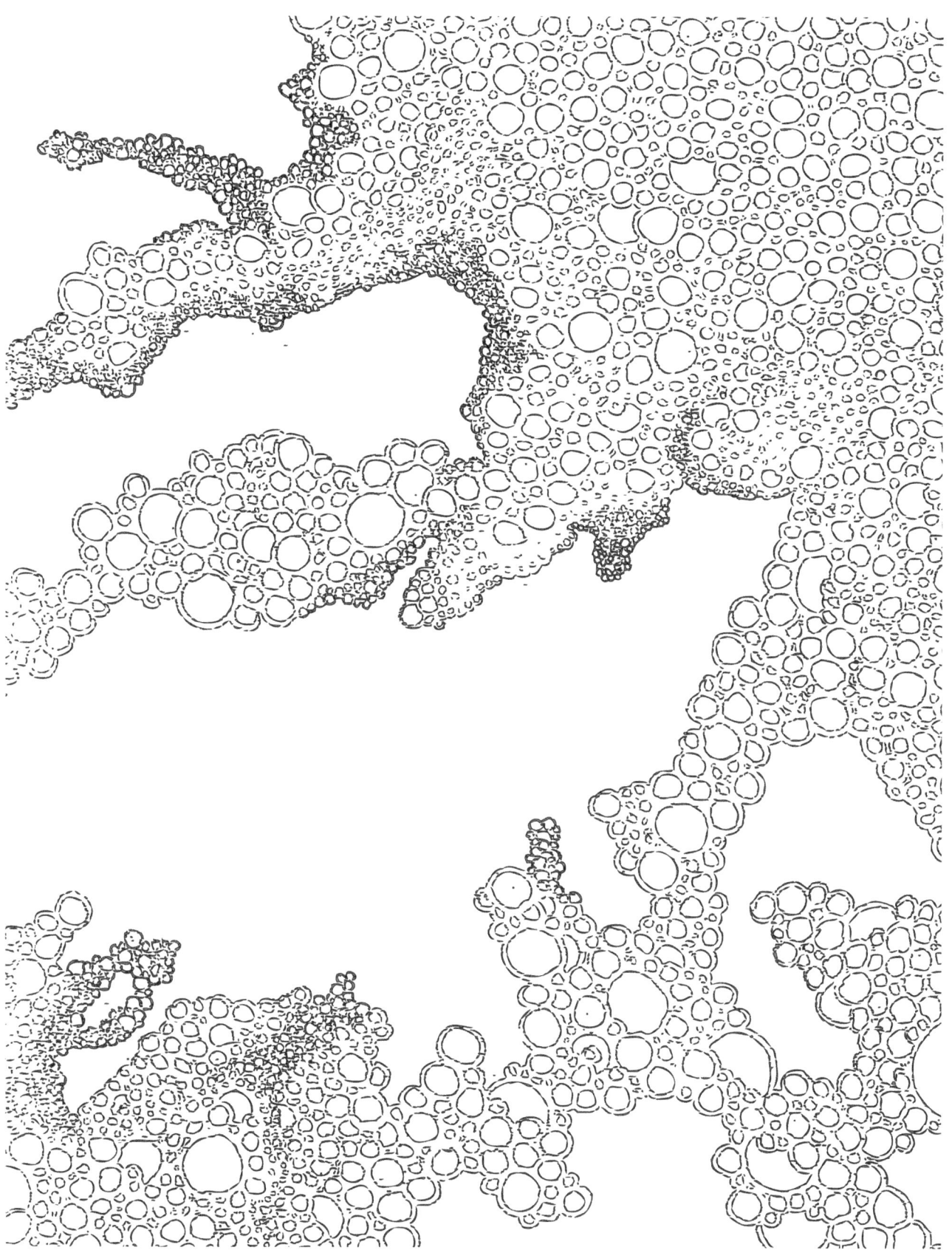

"Every child is an artist. The problem is how to remain an artist once he grows up."

Pablo Picasso

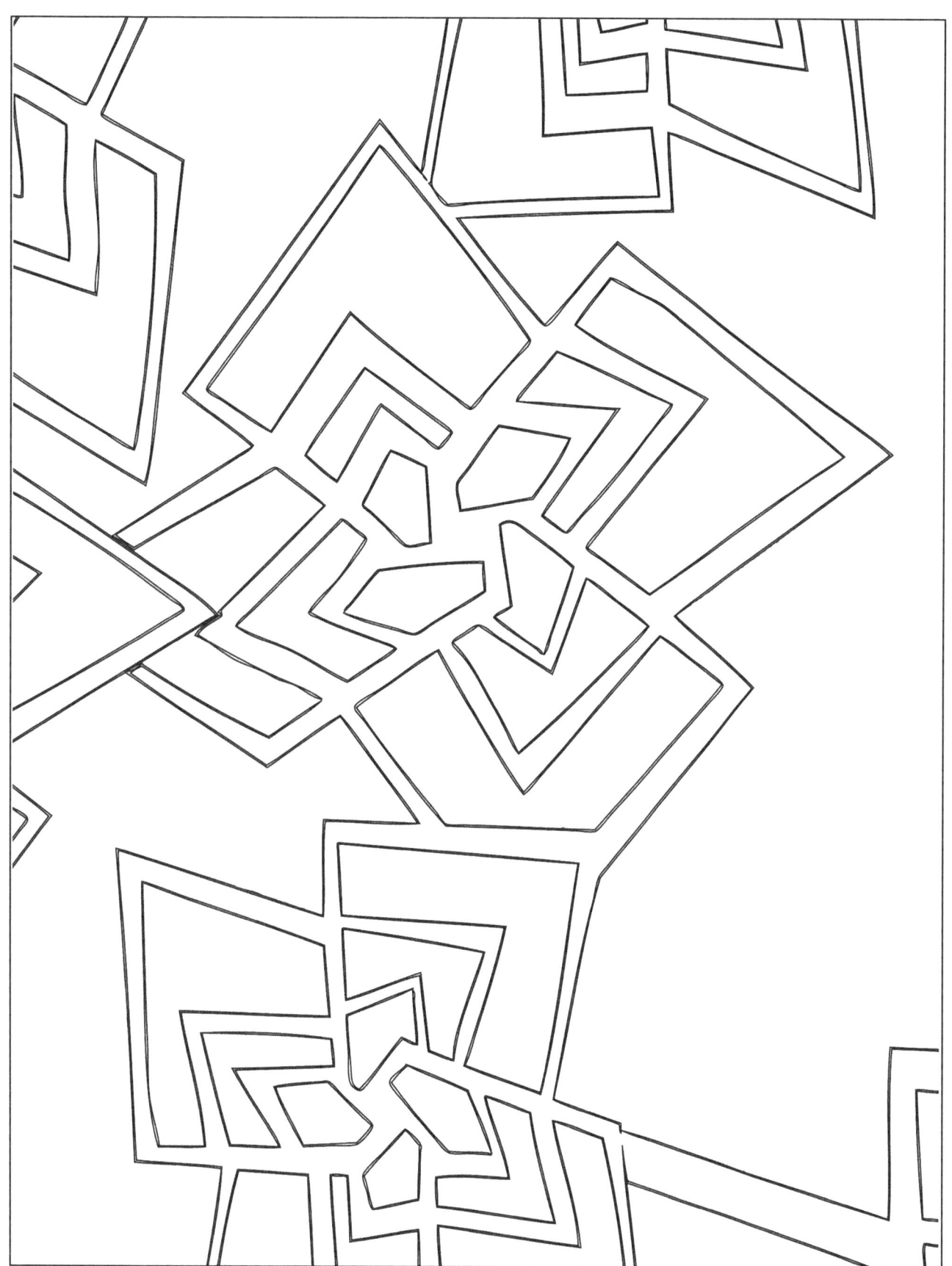

"Painting is poetry that is seen rather than felt,
and poetry is painting that is felt rather than seen."

Leonardo da Vinci

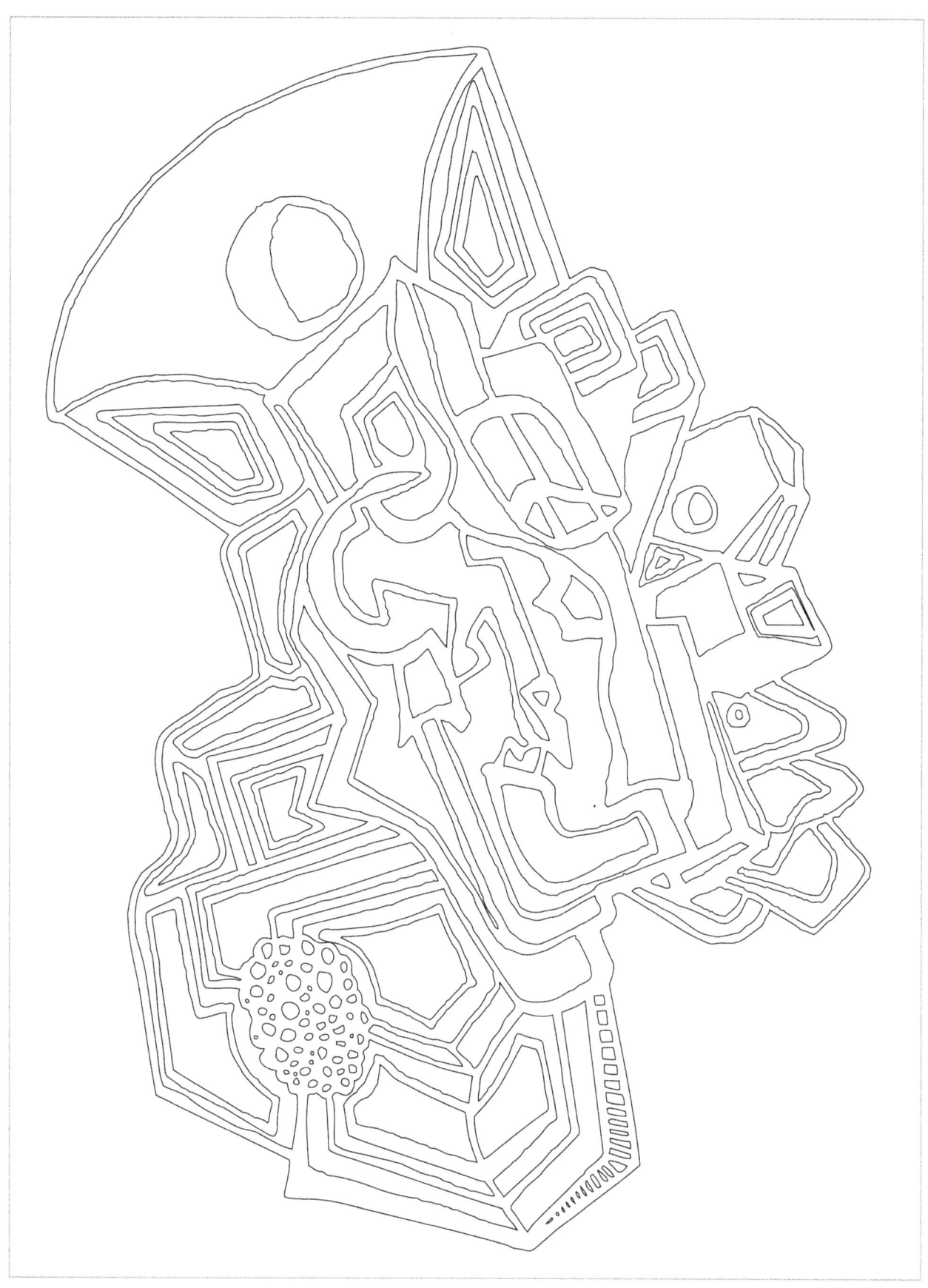

"Art enables us to find ourselves and lose ourselves at the same time."

Thomas Merton

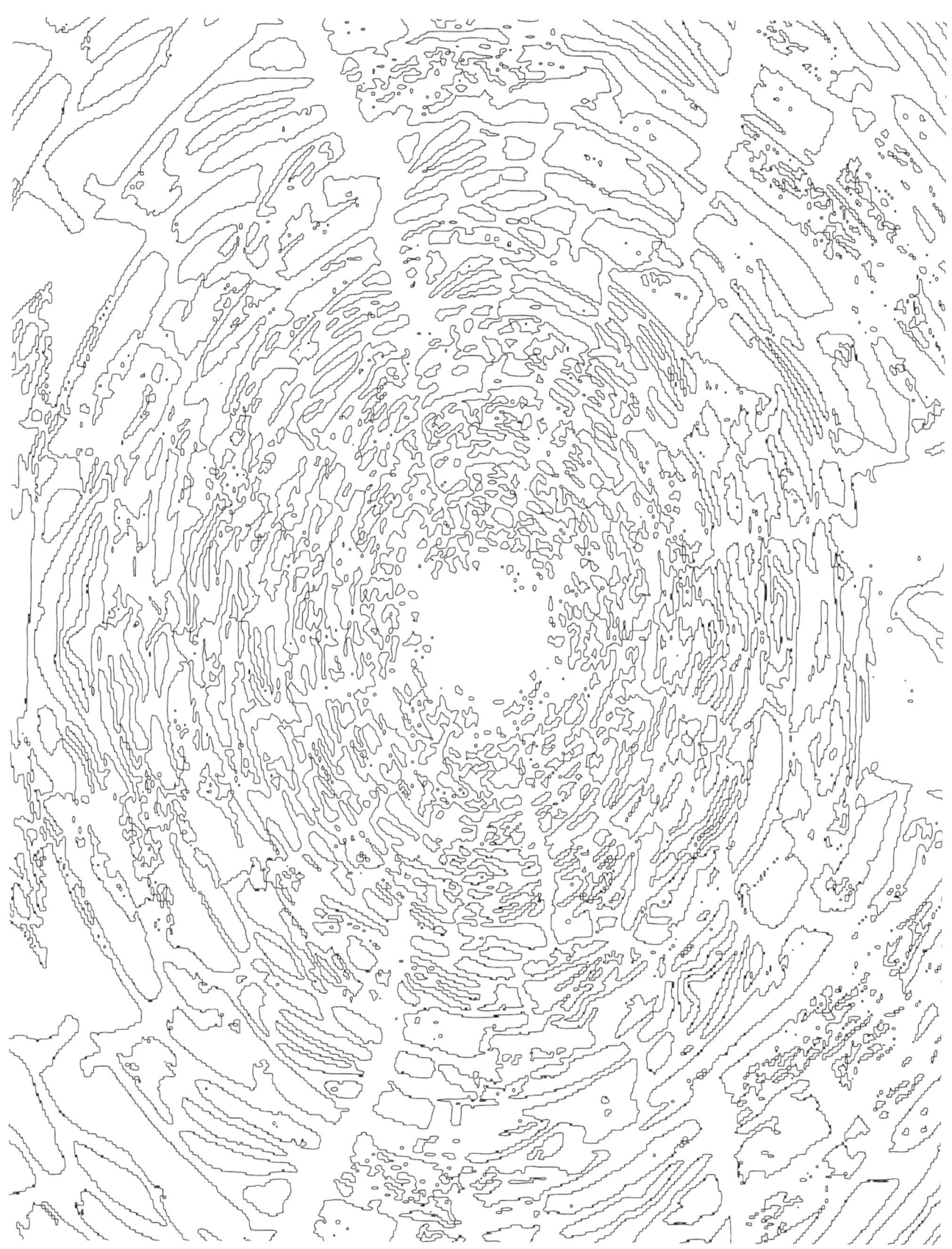

"Art is the only serious thing in the world. And the artist is the only person who is never serious."

Oscar Wilde

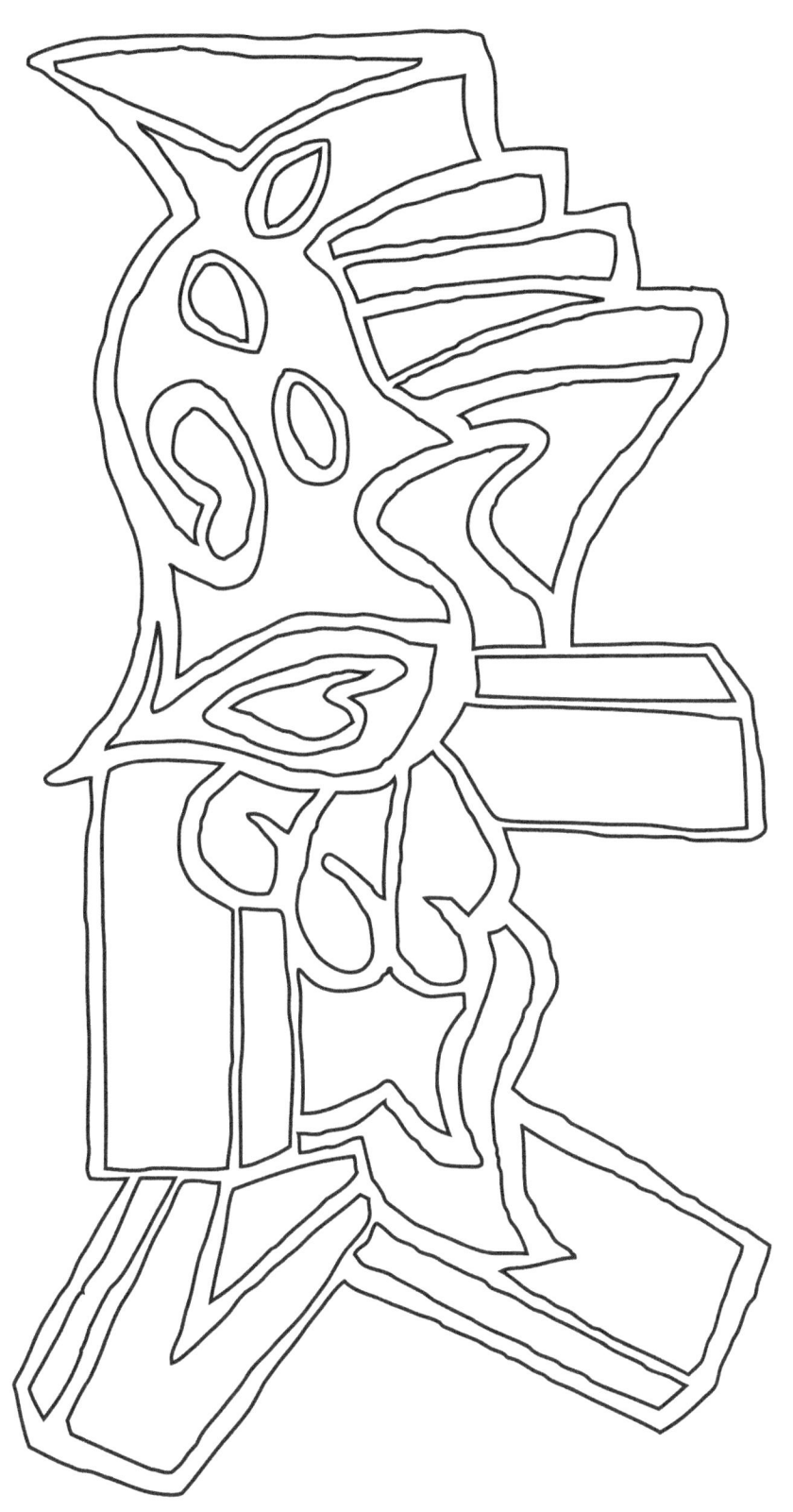

"Learn the rules like a pro, so you can break them like an artist."

Pablo Picasso

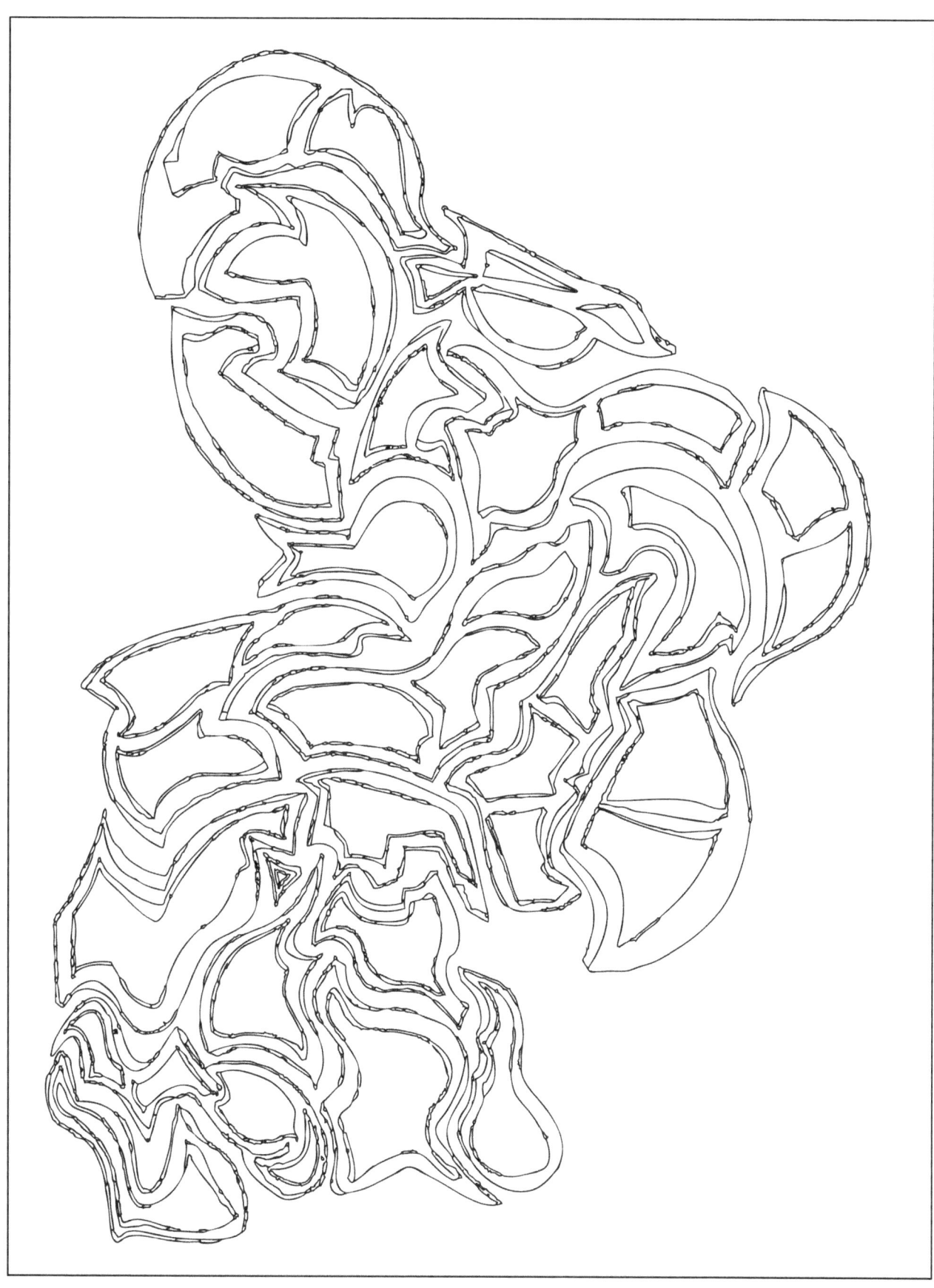

"The role of the artist is to ask questions, not answer them."

Anton Chekhov

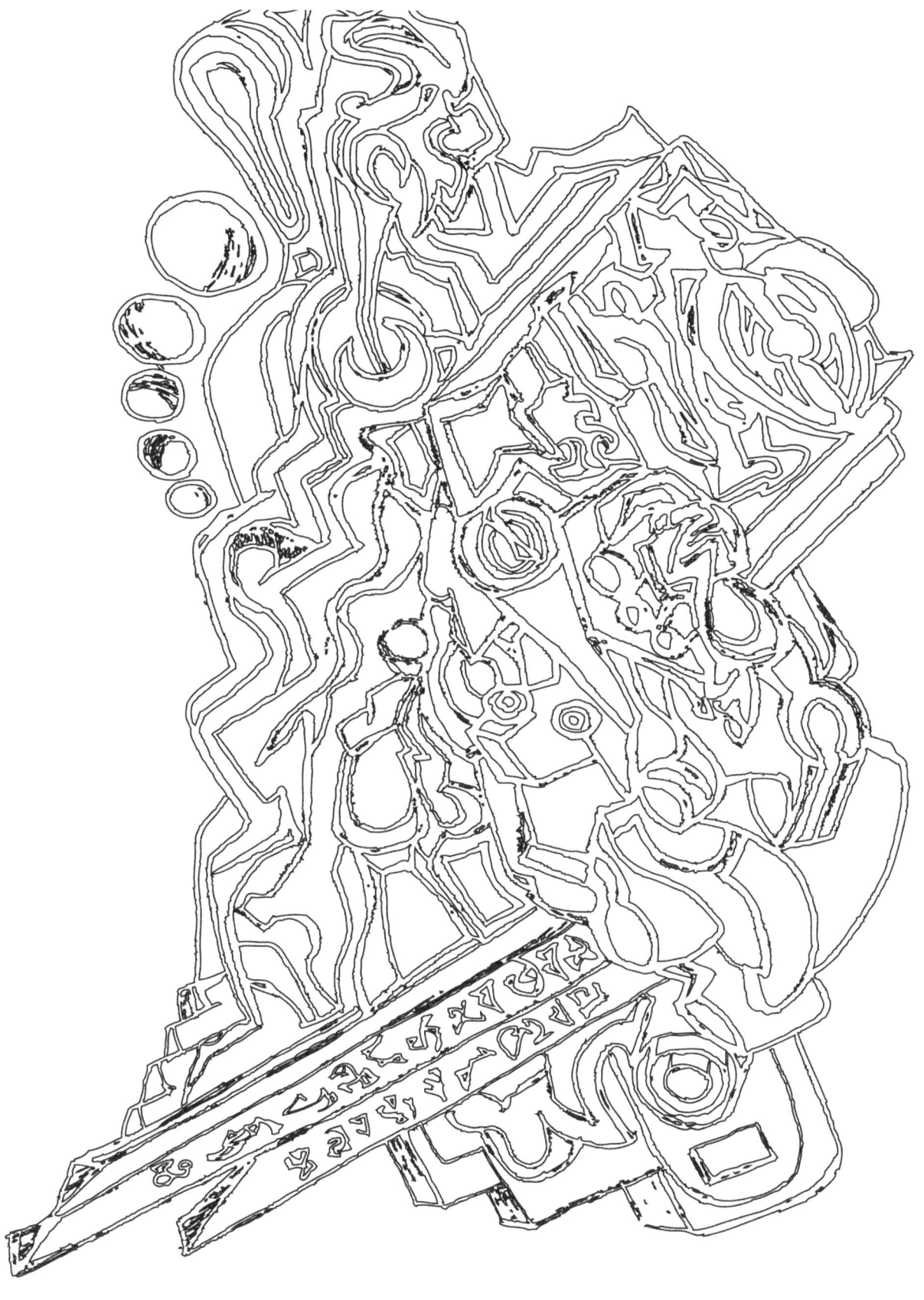

"You use a glass mirror to see your face;
you use works of art to see your soul."

George Bernard Shaw

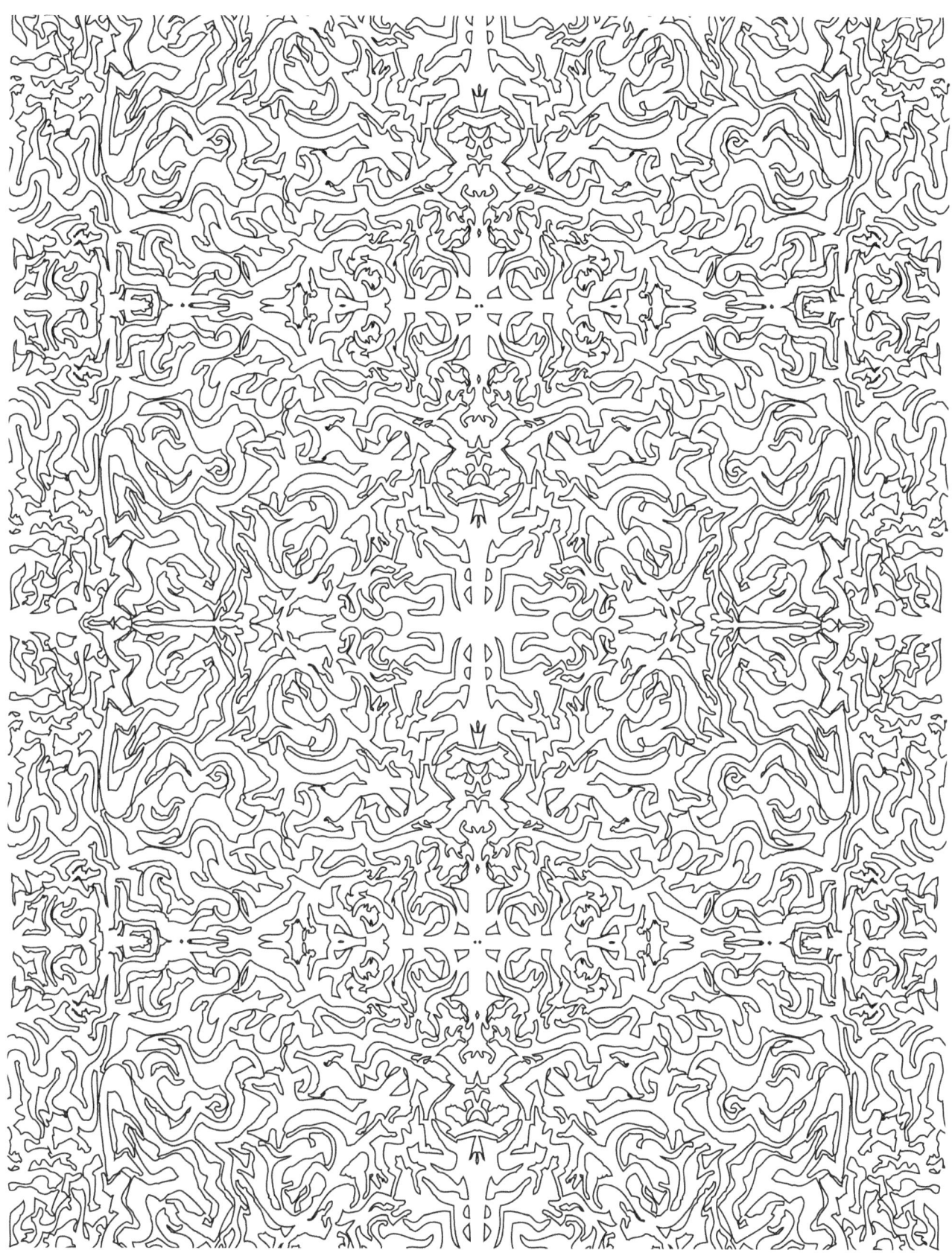

"Art is what you can get away with."

Andy Warhol

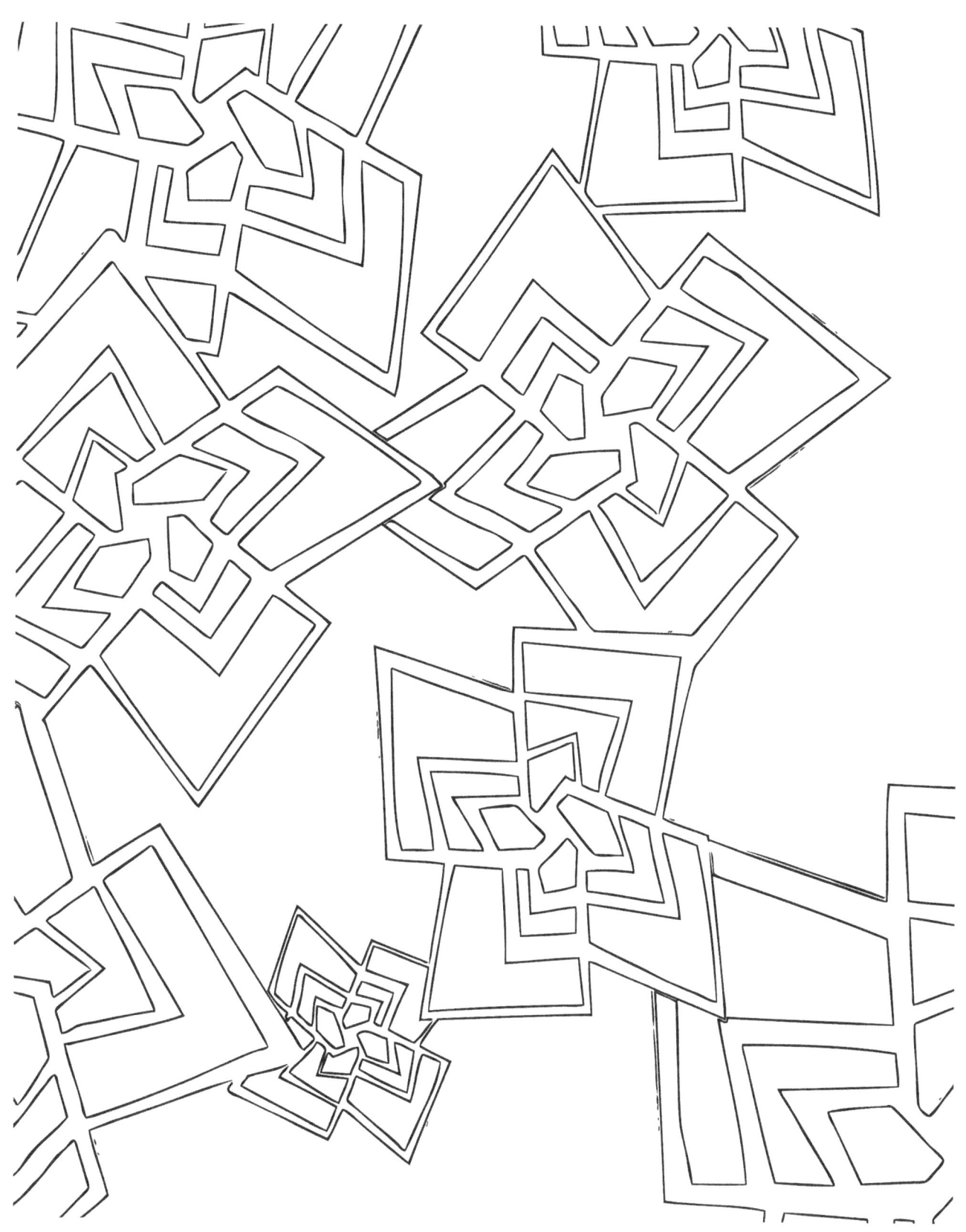

"Art is making something out of nothing, and selling it."

Frank Zappa

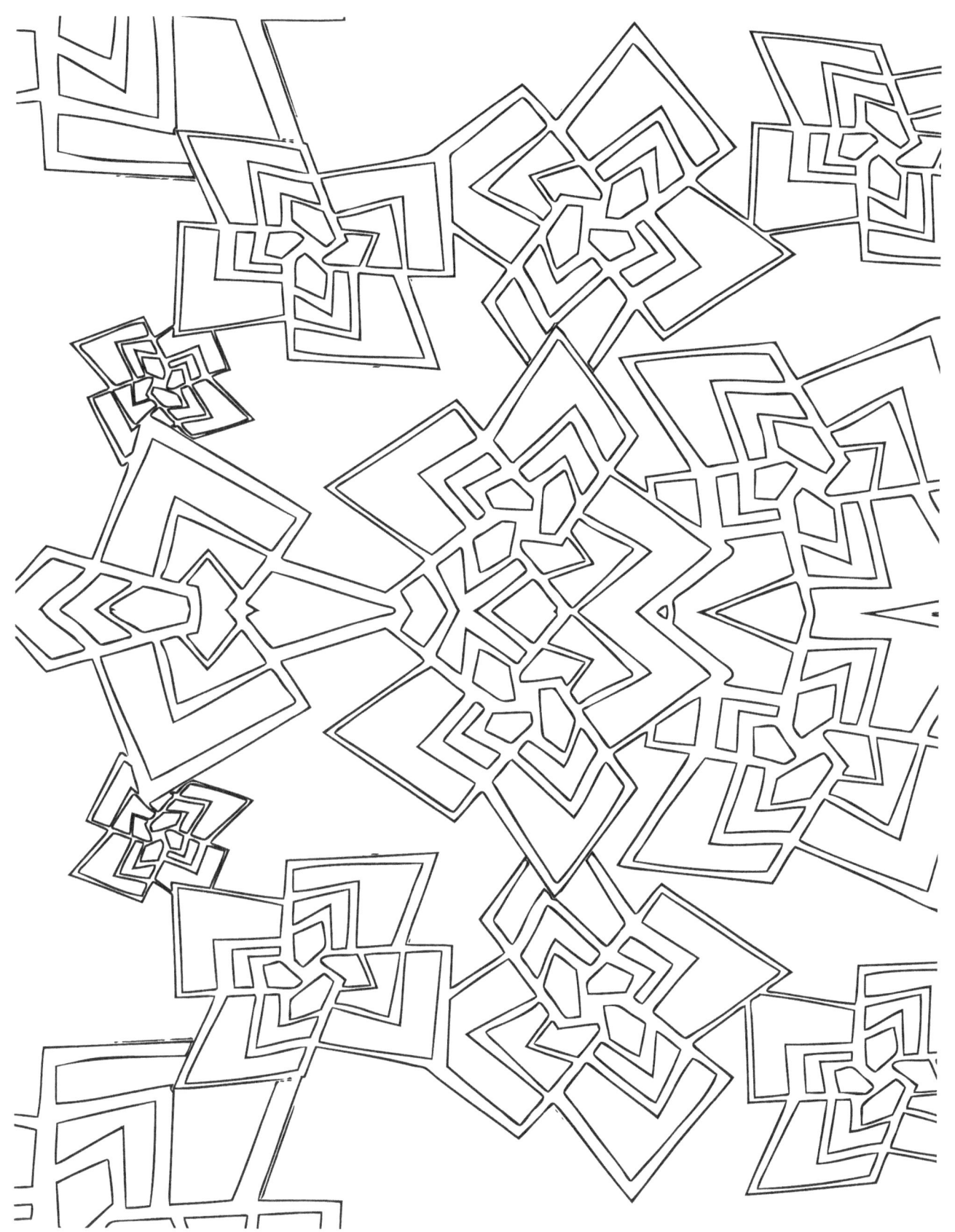

"The way to create art is to burn and destroy
ordinary concepts and to substitute them
with new truths that run down from the
top of the head and out of the heart."

Charles Bukowski

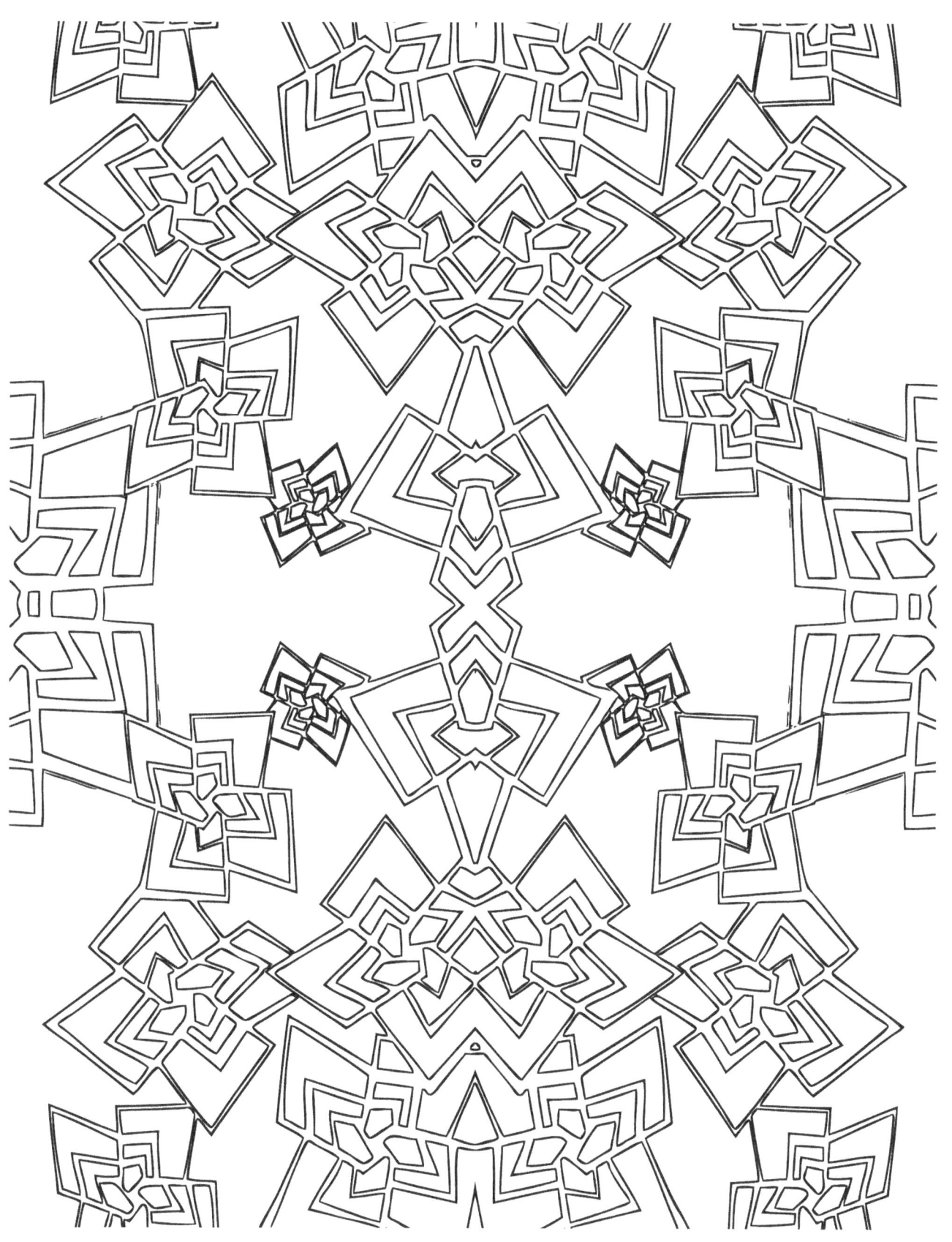

"The absence of limitations is the enemy of art."

Orson Welles

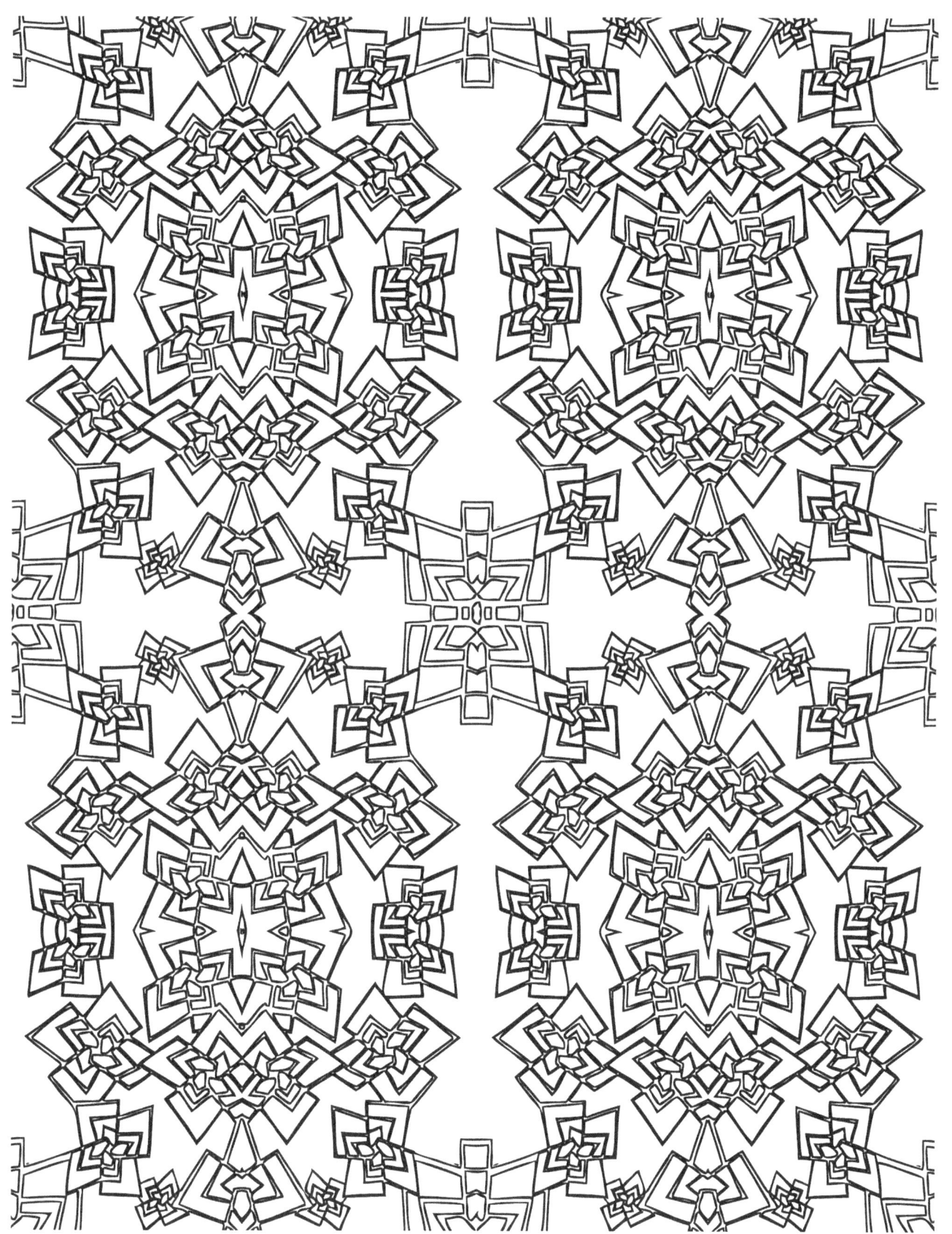

"Works of art, in my opinion, are the only objects in the material universe to possess internal order, and that is why, though I don't believe that only art matters, I do believe in Art for Art's sake."

E.M. Forster

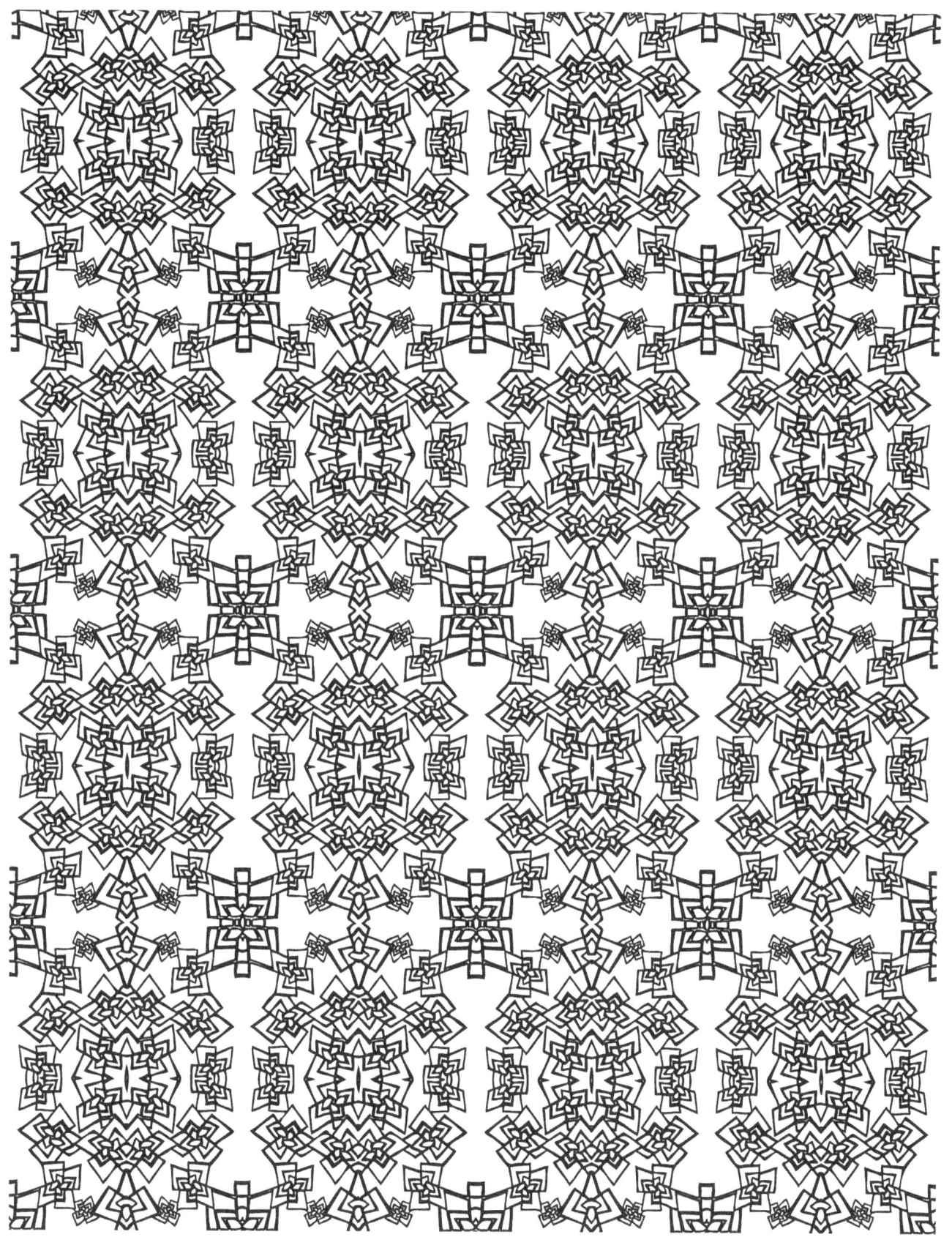

"If we can't, as artists, improve on real life, we should put down our pencils and go bake bread."

Barbara Kingsolver

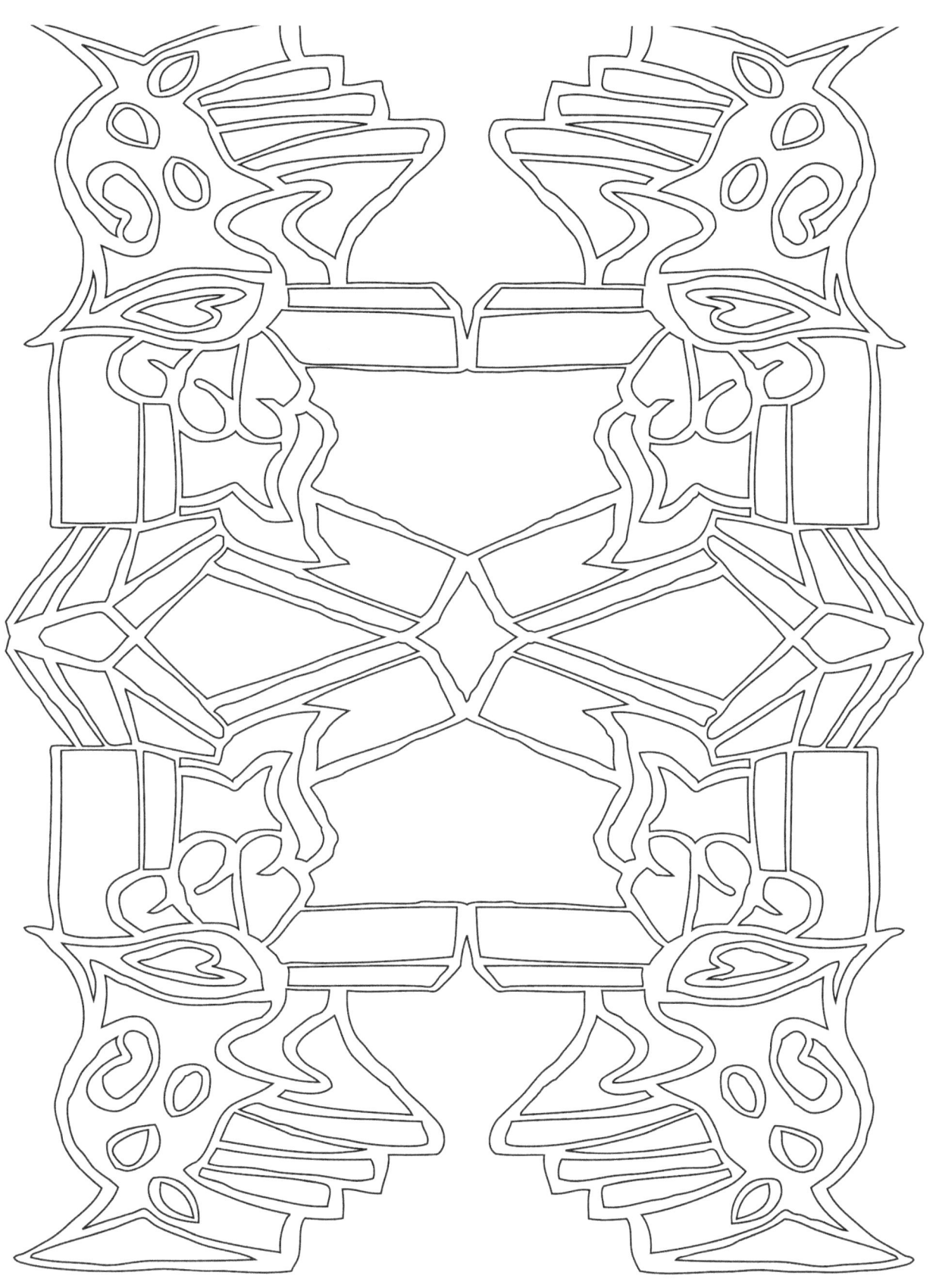

"Art and life are subjective. Not everybody's gonna dig what I dig, but I reserve the right to dig it."

Whoopi Goldberg

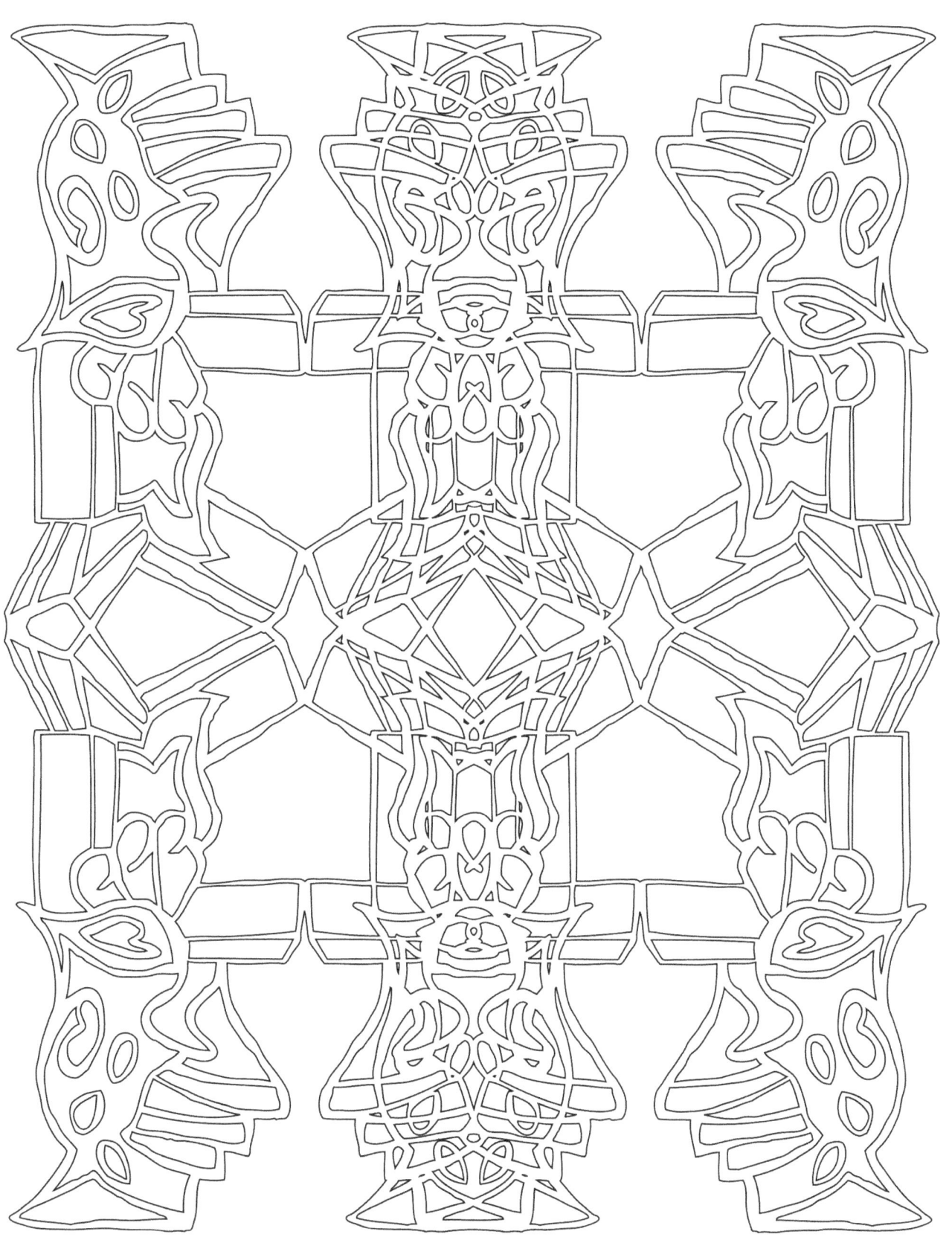

"In art as in love, instinct is enough."

Anatole France

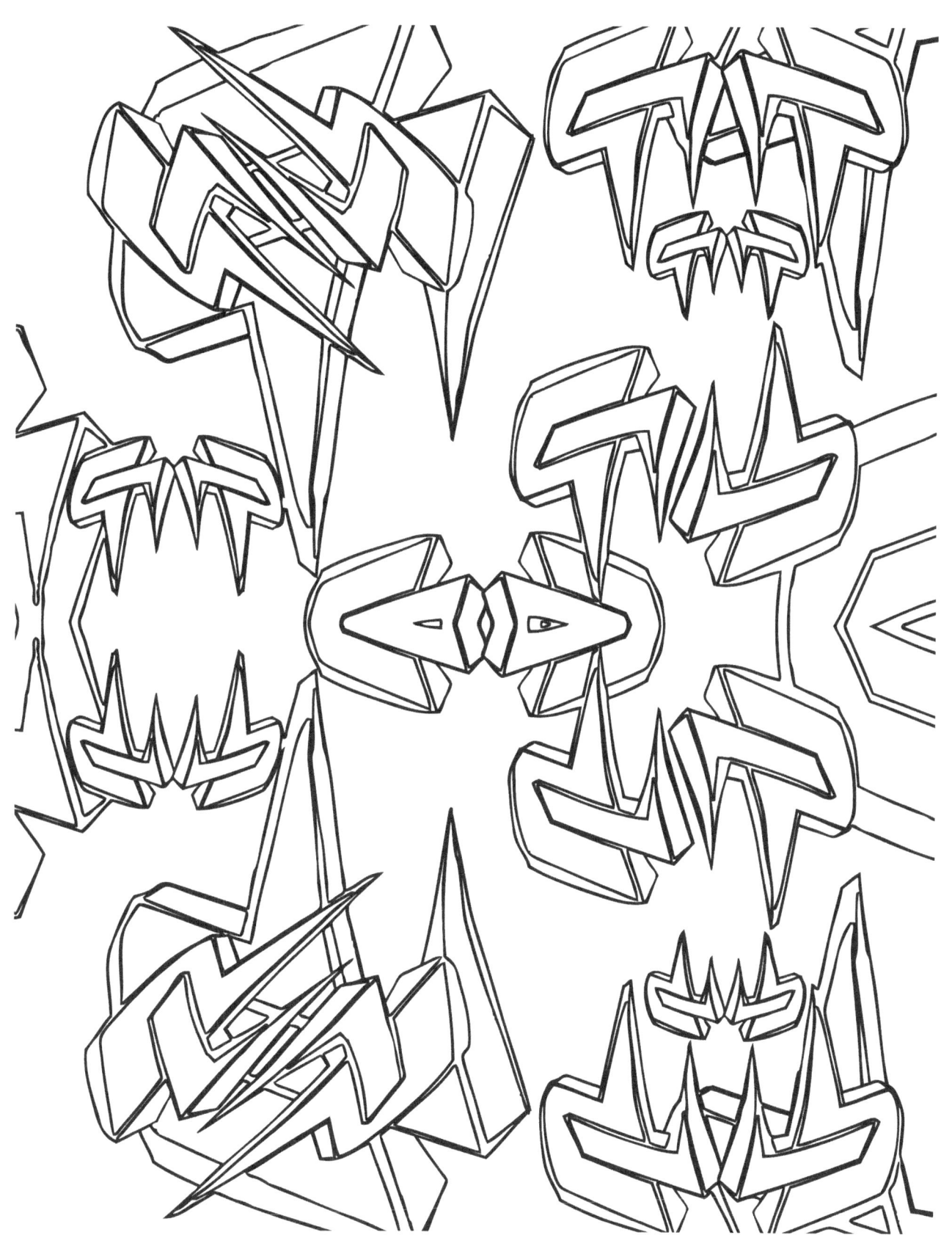

"I found I could say things with color and shapes that
I couldn't say any other way... things I had no words for."

Georgia O'Keefe

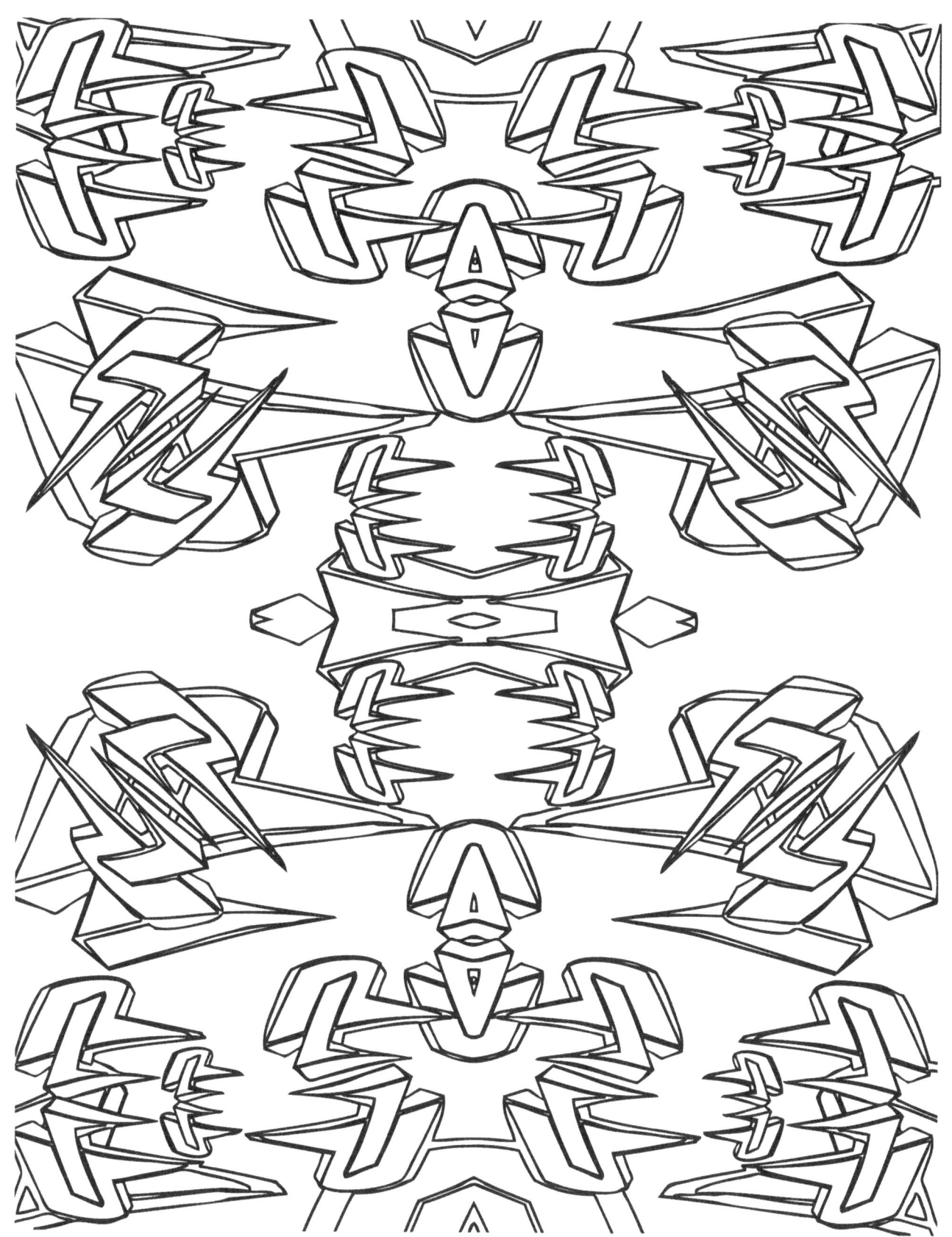

"Whoever uses the spirit that is in him creatively is an artist.
To make living itself an art, that is the goal."

Henry Miller

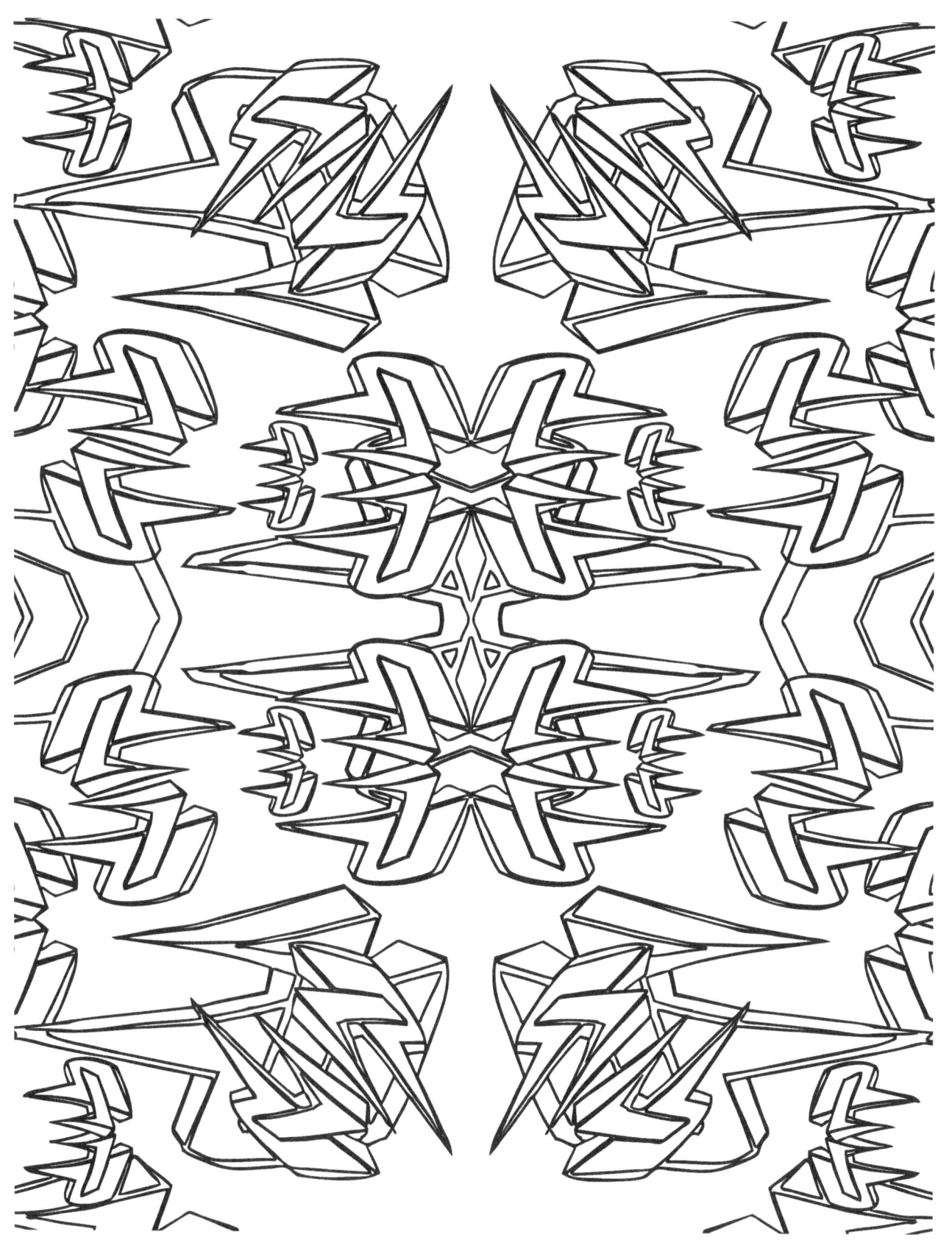

"The object isn't to make art, it's to be in that wonderful state which makes art inevitable."

Robert Henri

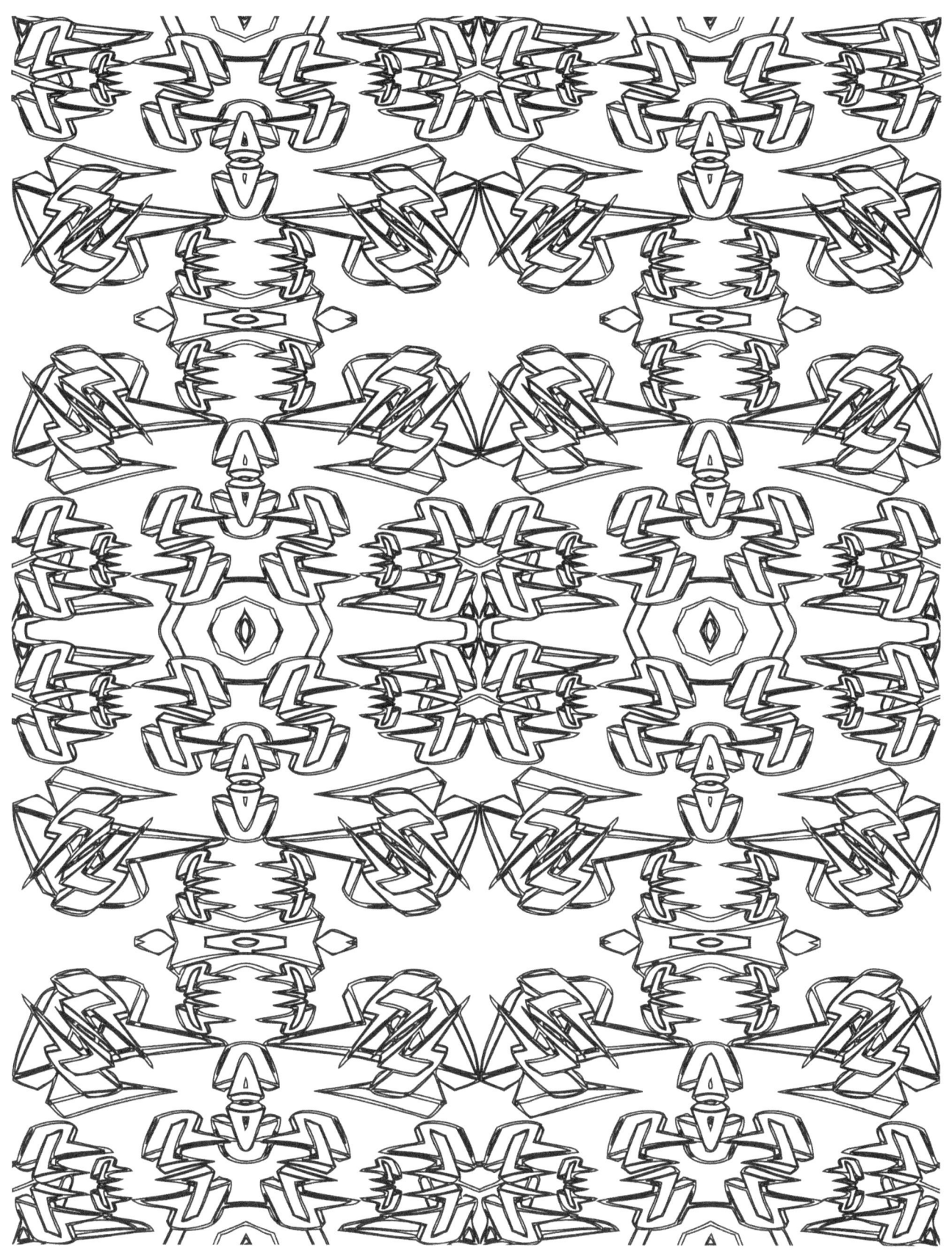

"Only in art will the lion lie down with the lamb, and the rose grow without thorn."

Martin Amis

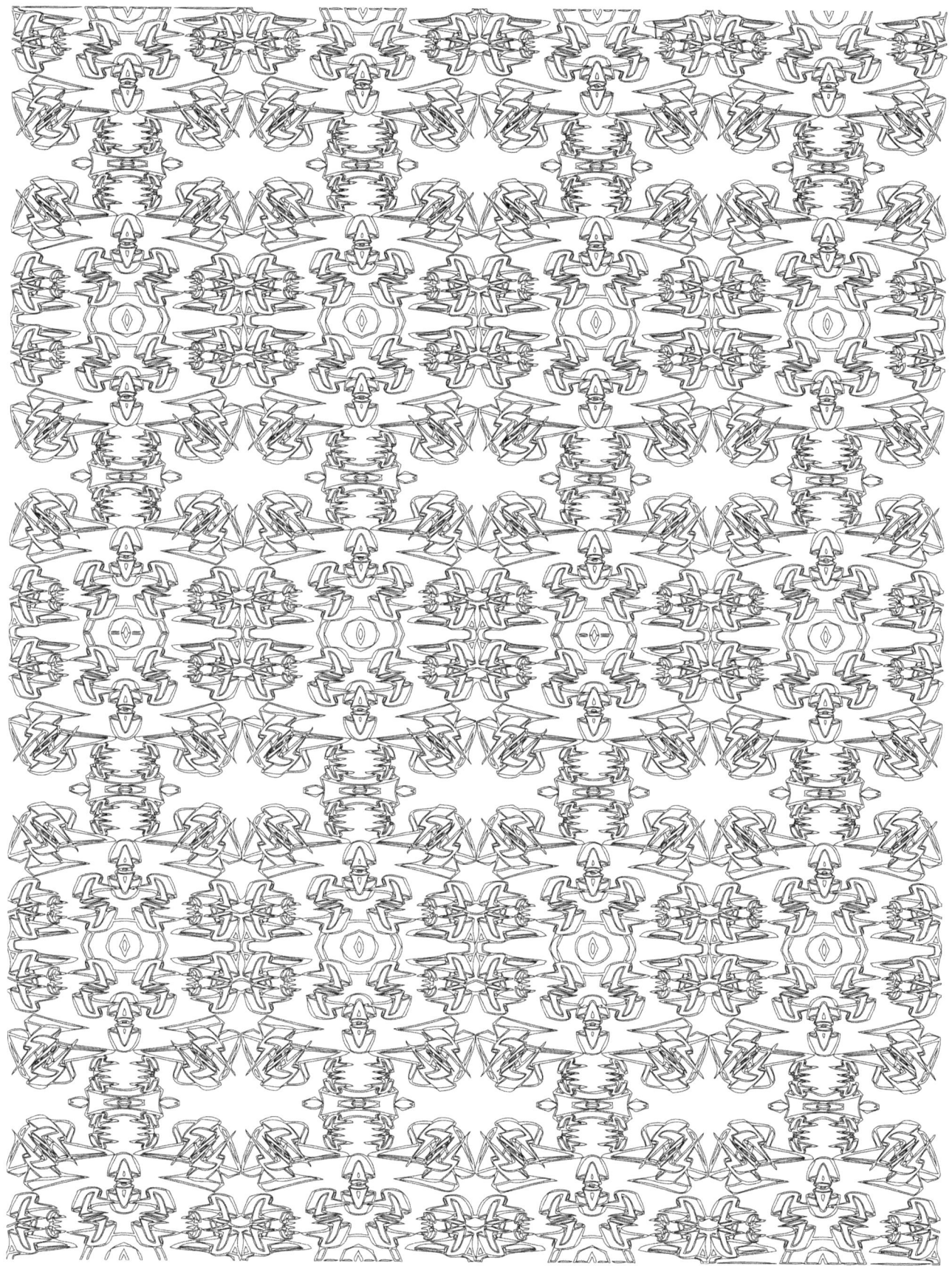

"I don't believe in art. I believe in artists."

Marcel Duchamp

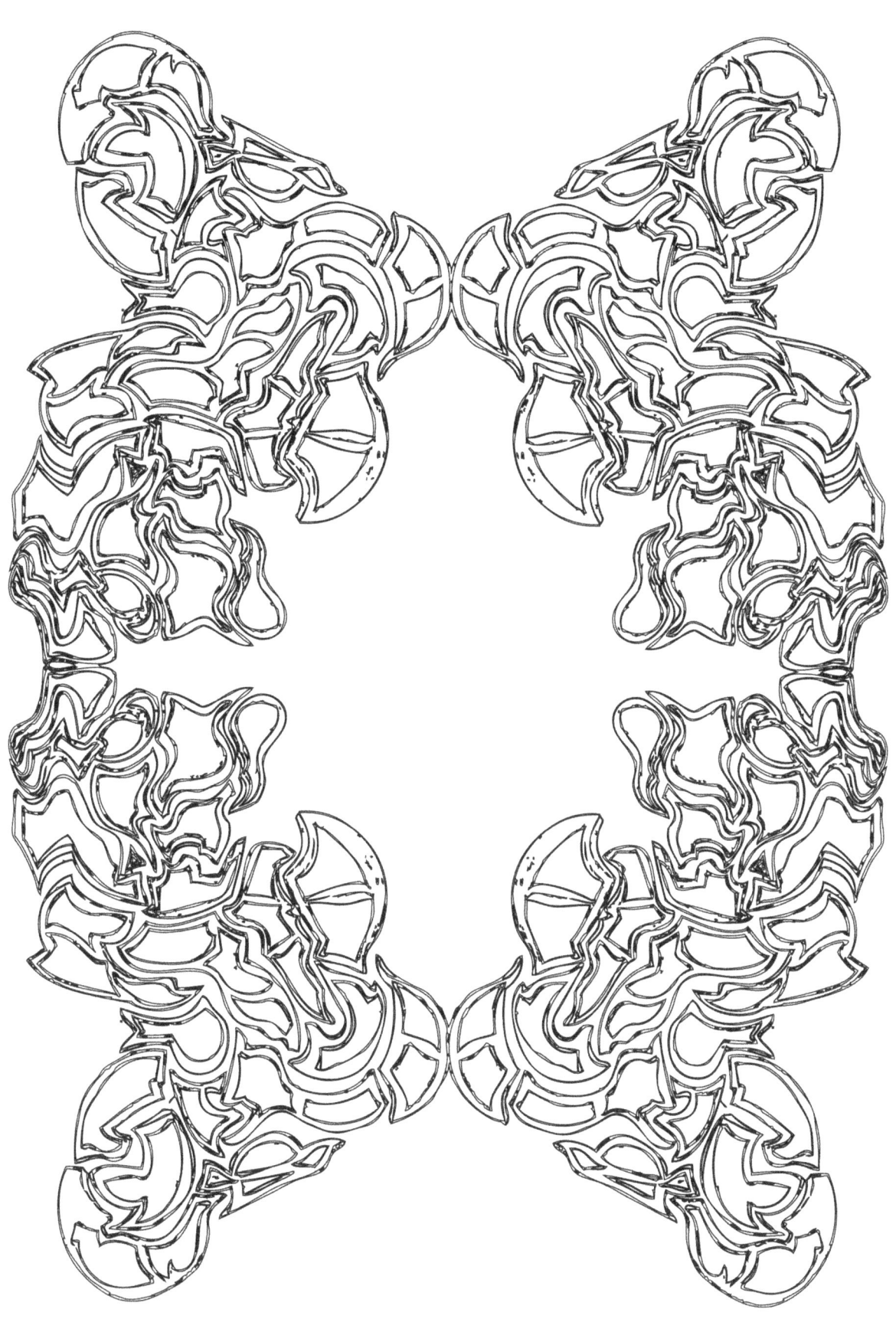

"Art is science made clear."

Jean Cocteau

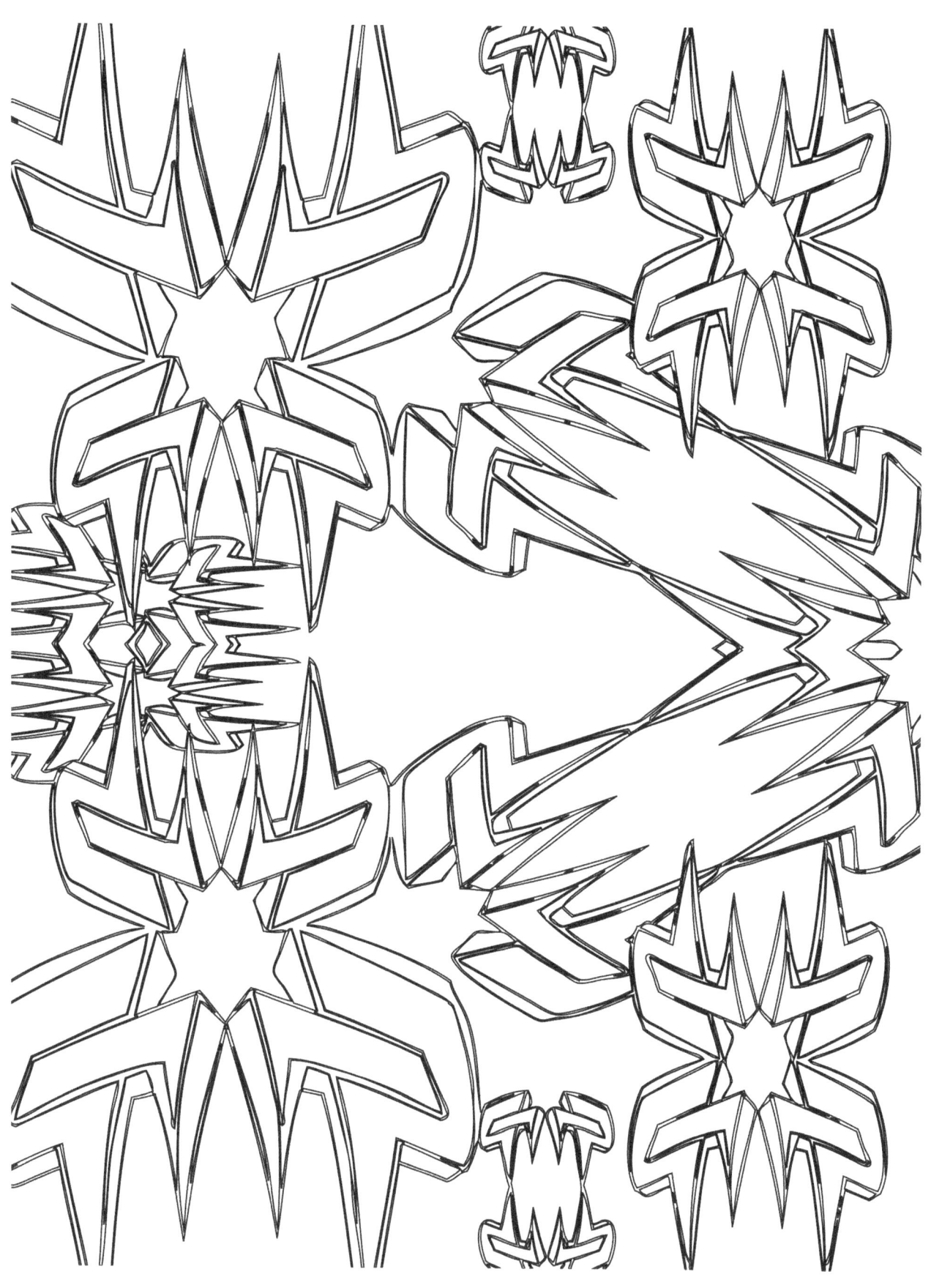

"If you could say it in words, there would be no reason to paint."

Edward Hopper

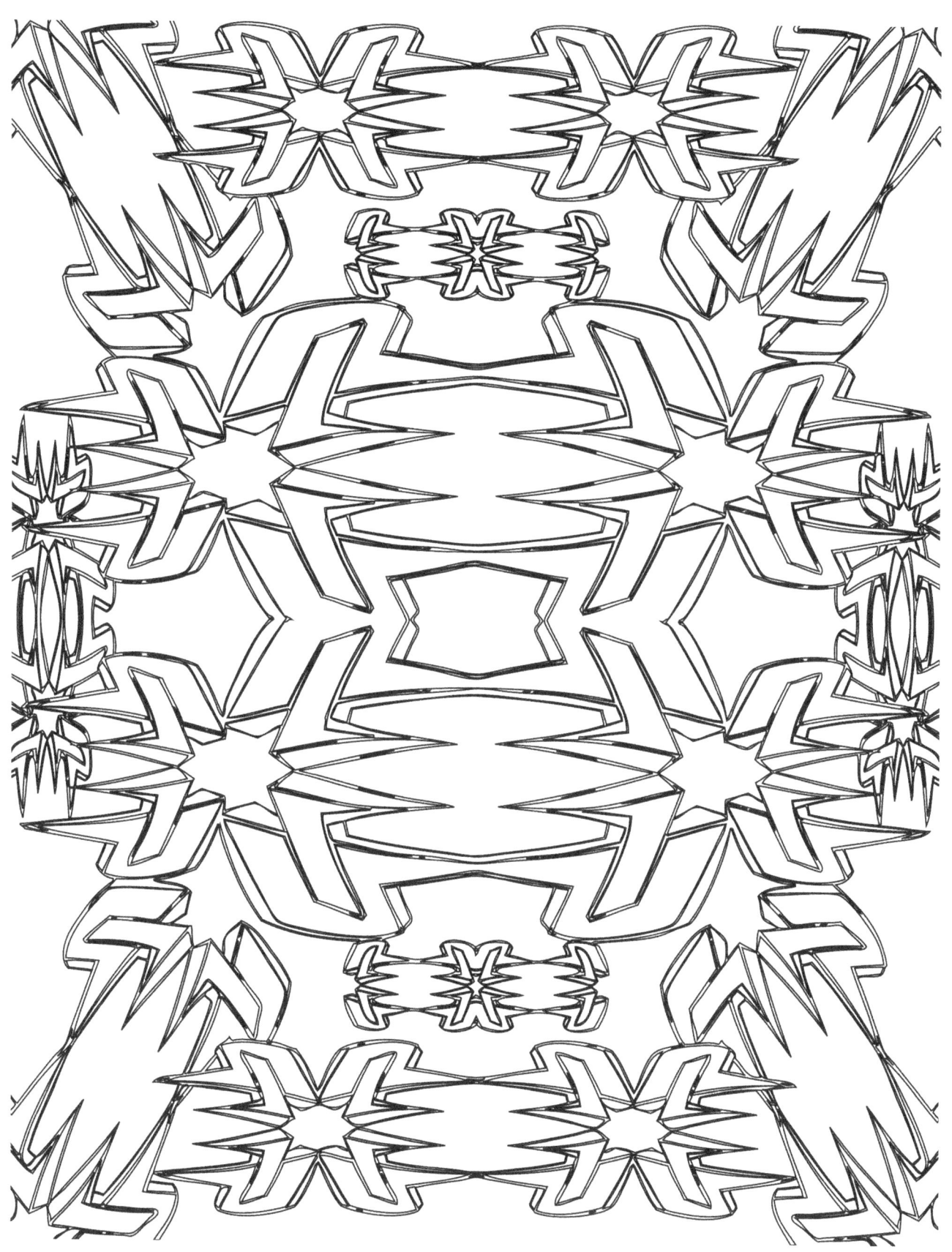

"How many times have people used a pen or paintbrush because they couldn't pull the trigger?"

Virginia Woolf

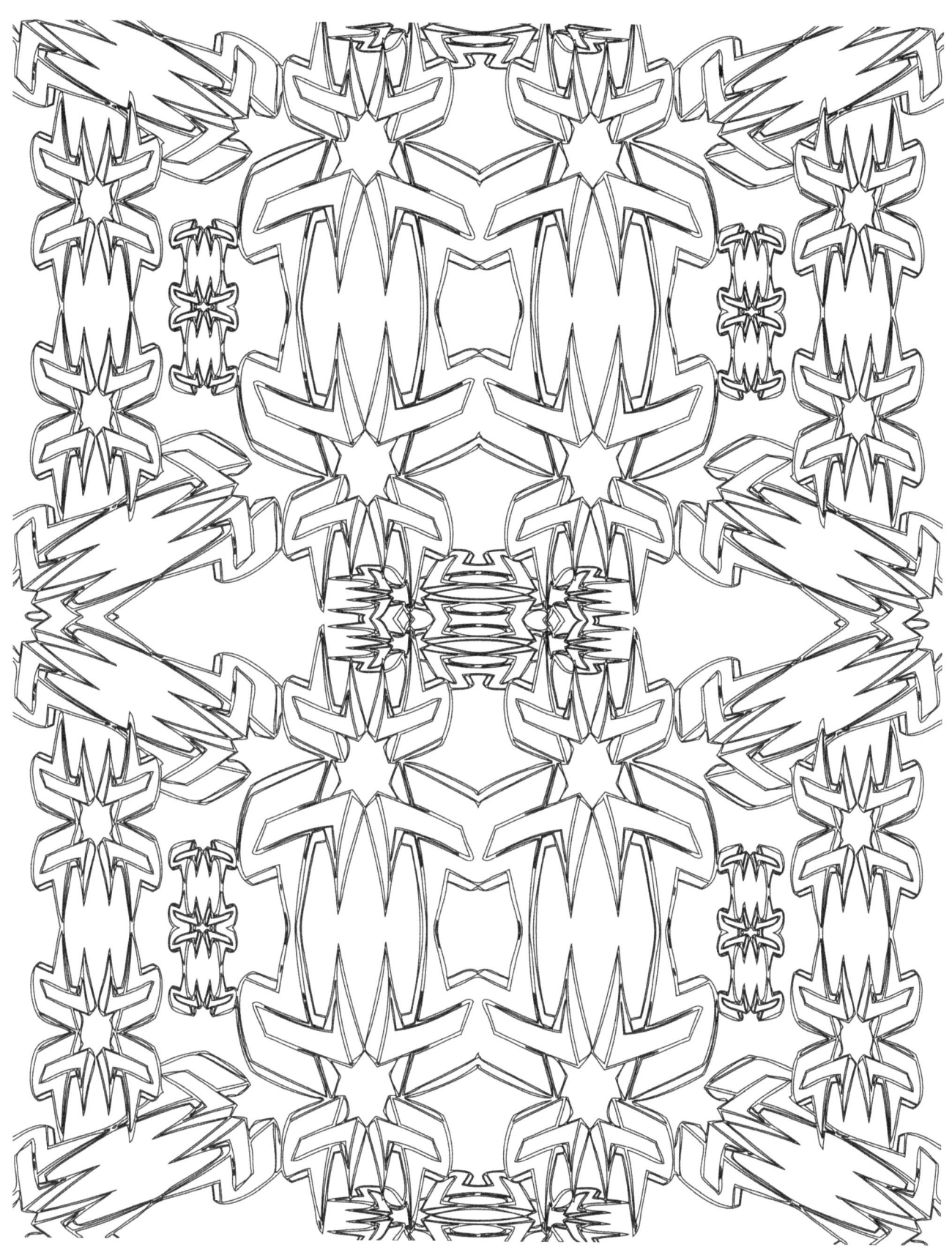

"Art is either revolution or plagiarism."

Paul Gaughin

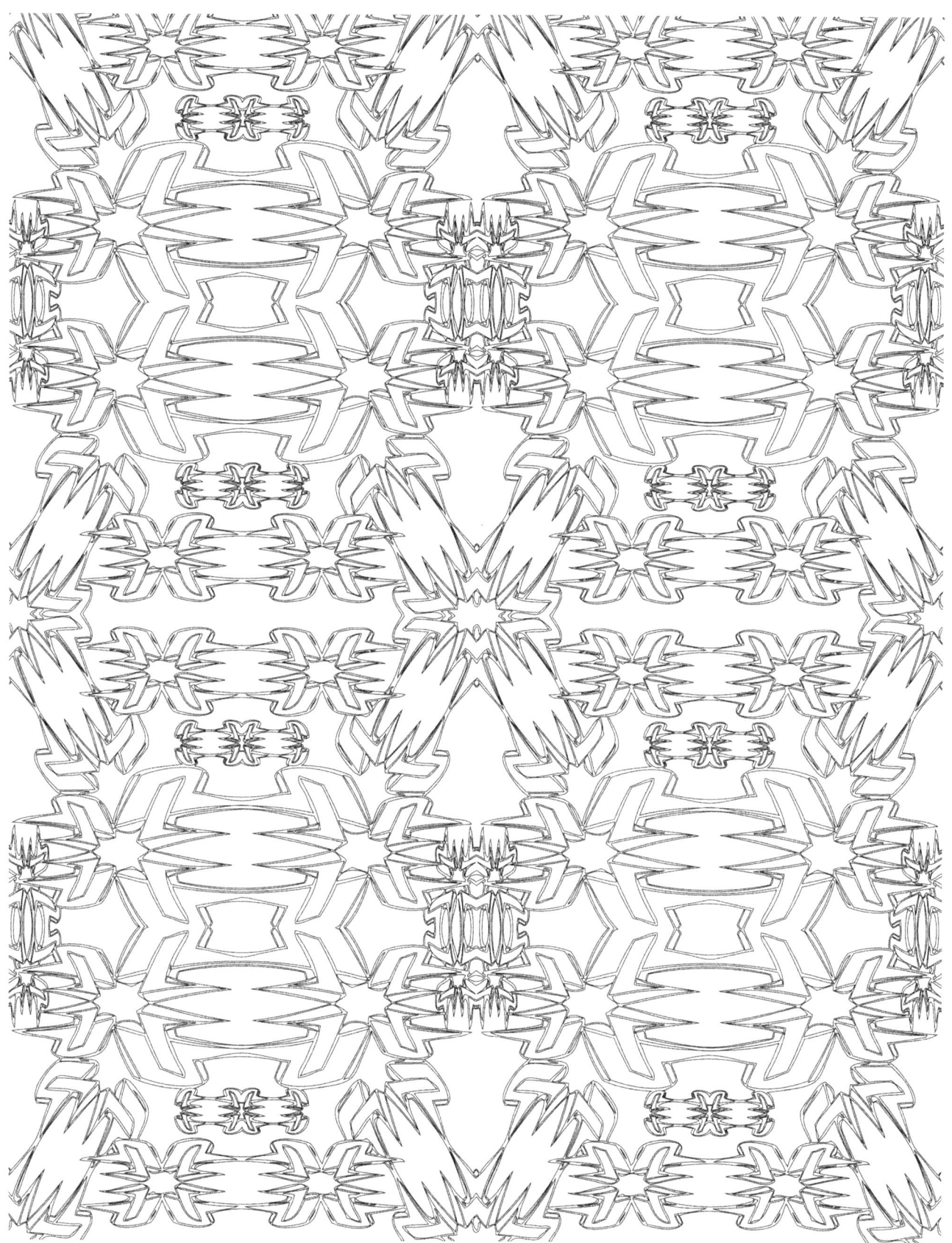

"To consult the rules of composition before making a picture is a little like consulting the law of gravitation before going for a walk."

Edward Weston

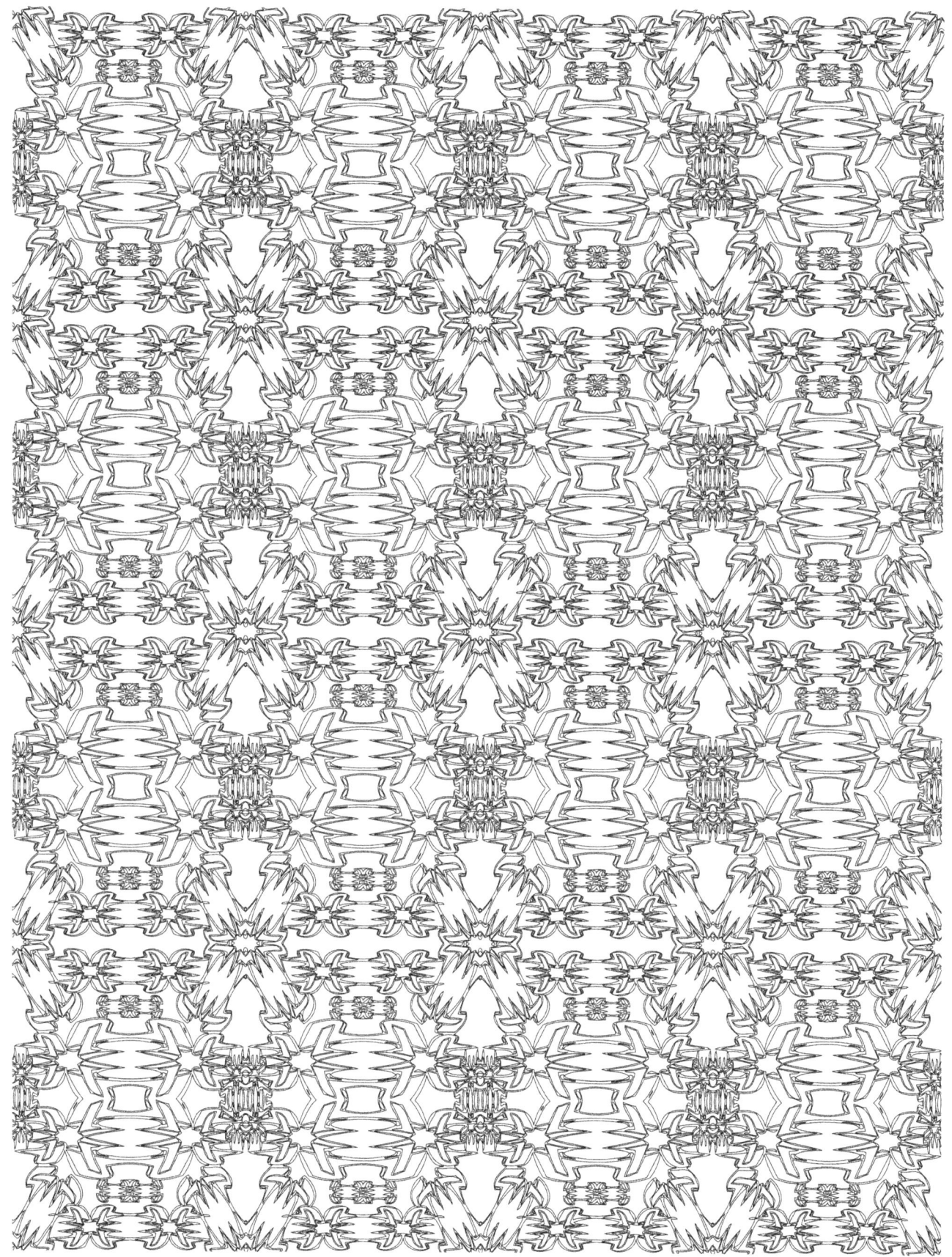

"Art is not a thing; it is a way."

Elbert Hubbard

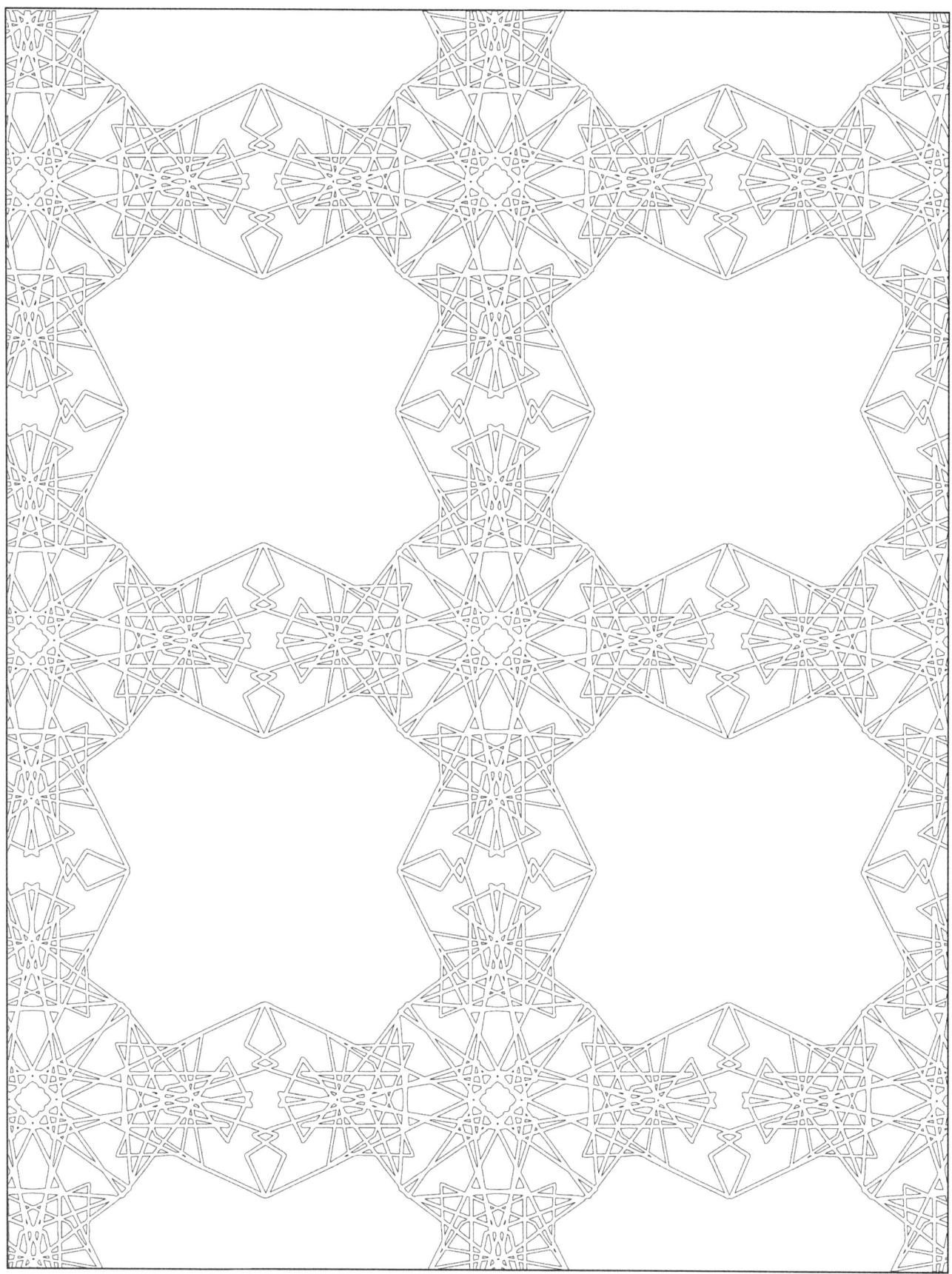

"A guilty conscience needs to confess. A work of art is a confession."

Albert Camus

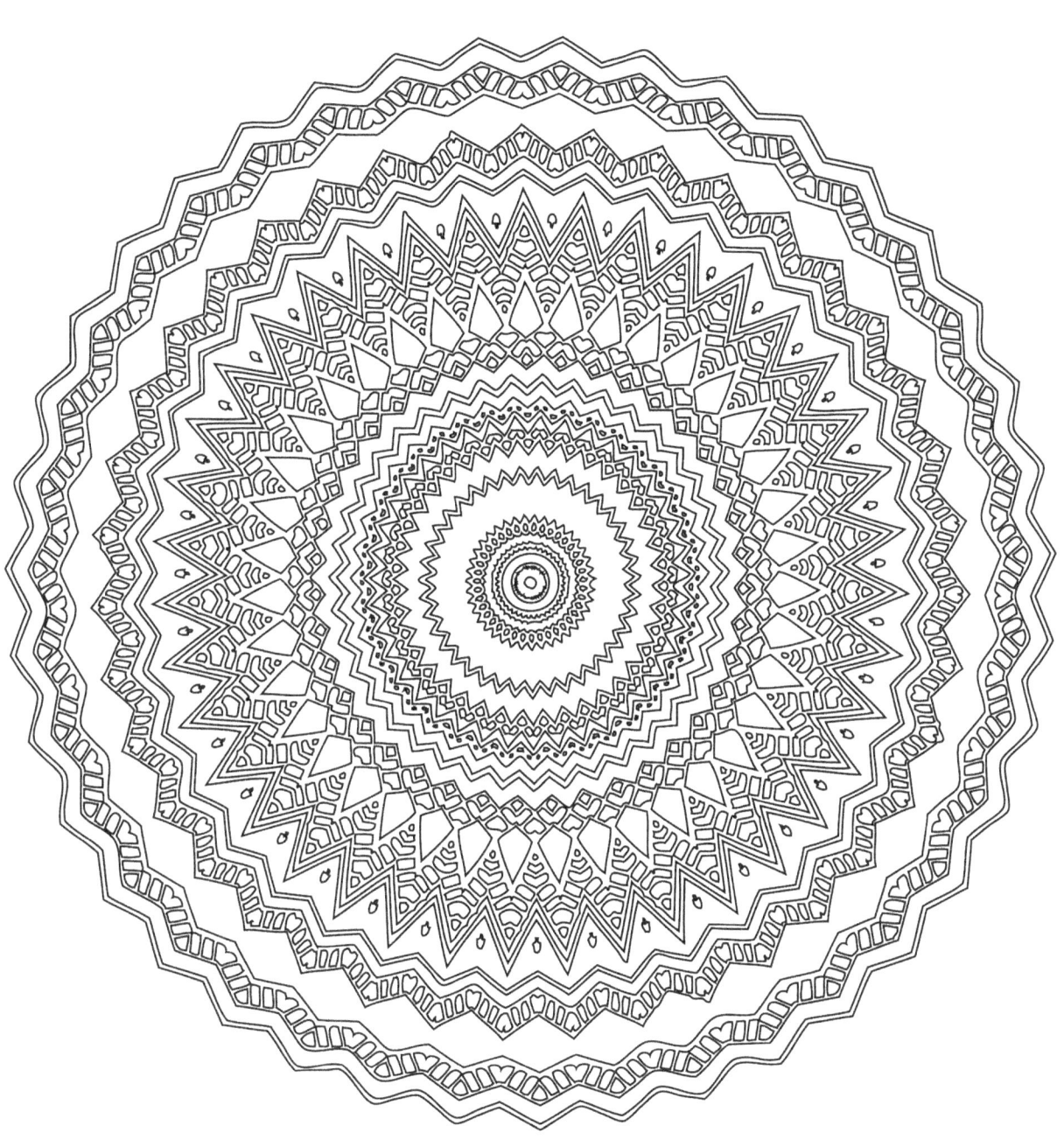

"Serious art is born from serious play."

Julia Cameron

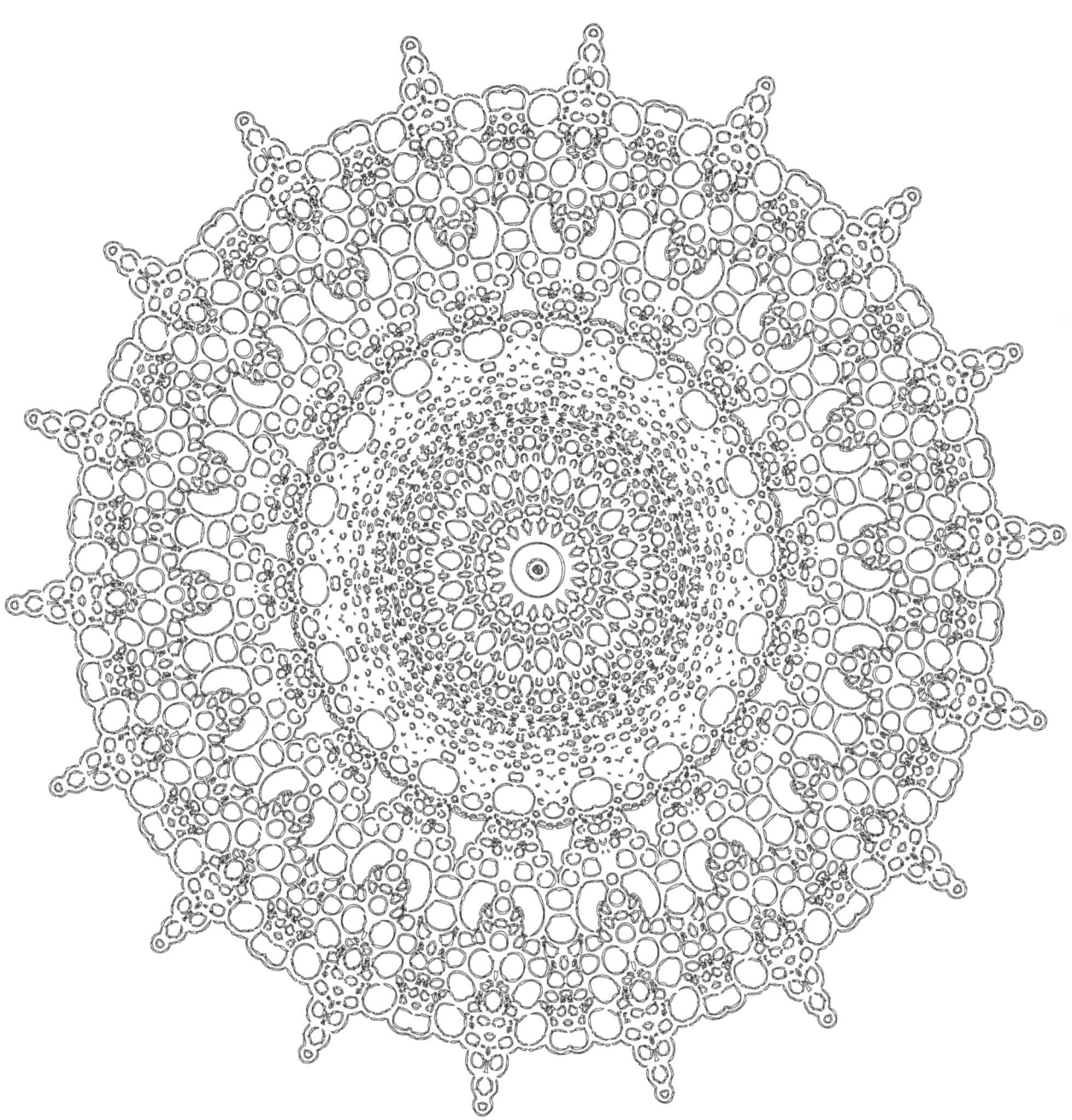

"Great art is the outward expression of an inner life in the artist, and this inner life will result in his personal vision of the world."

Edward Hopper

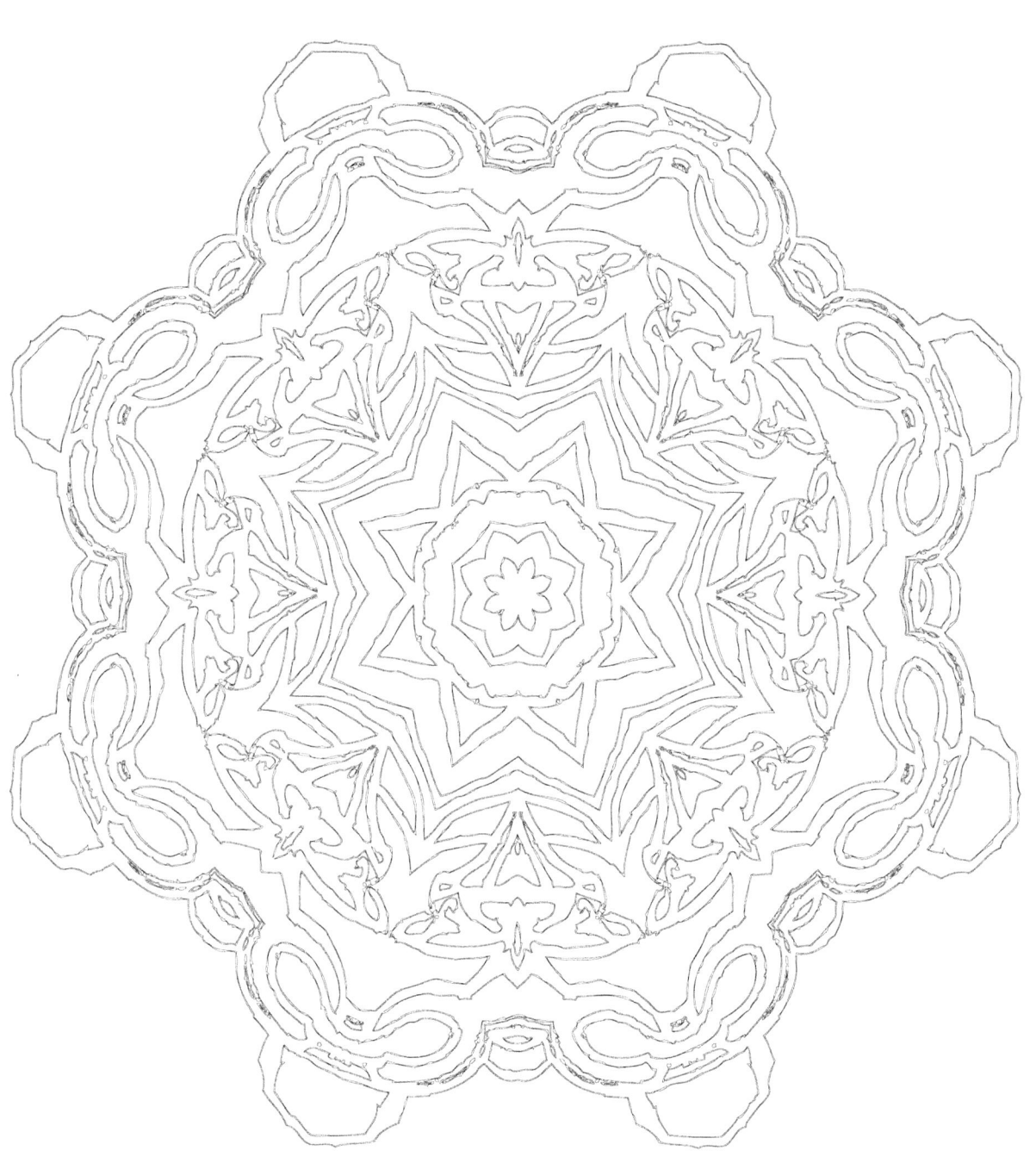

"I would rather fail as an artist than succeed as anything else."

Robert Dowling

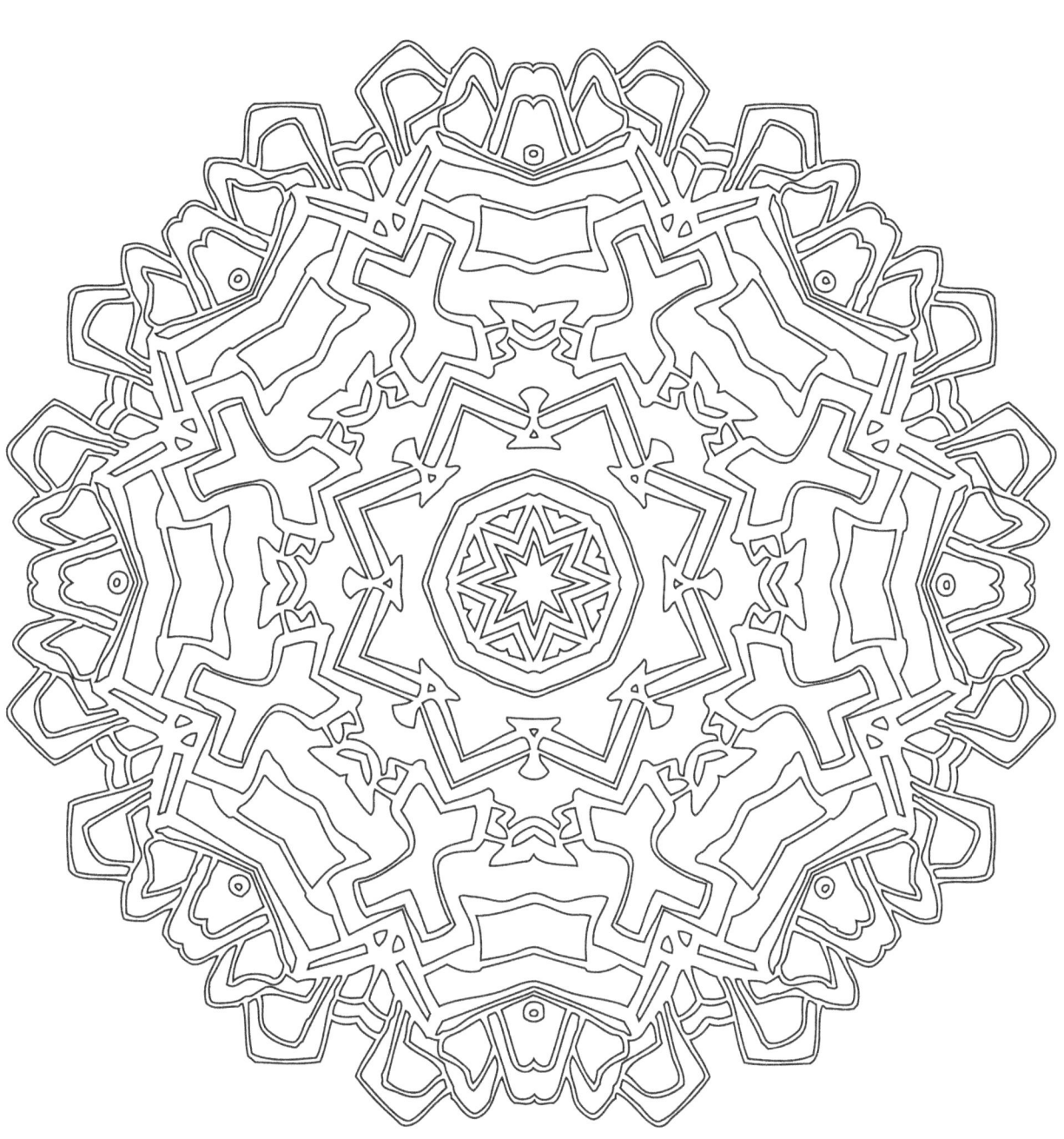

"Art does not reproduce the visible; it makes visible."

Paul Klee

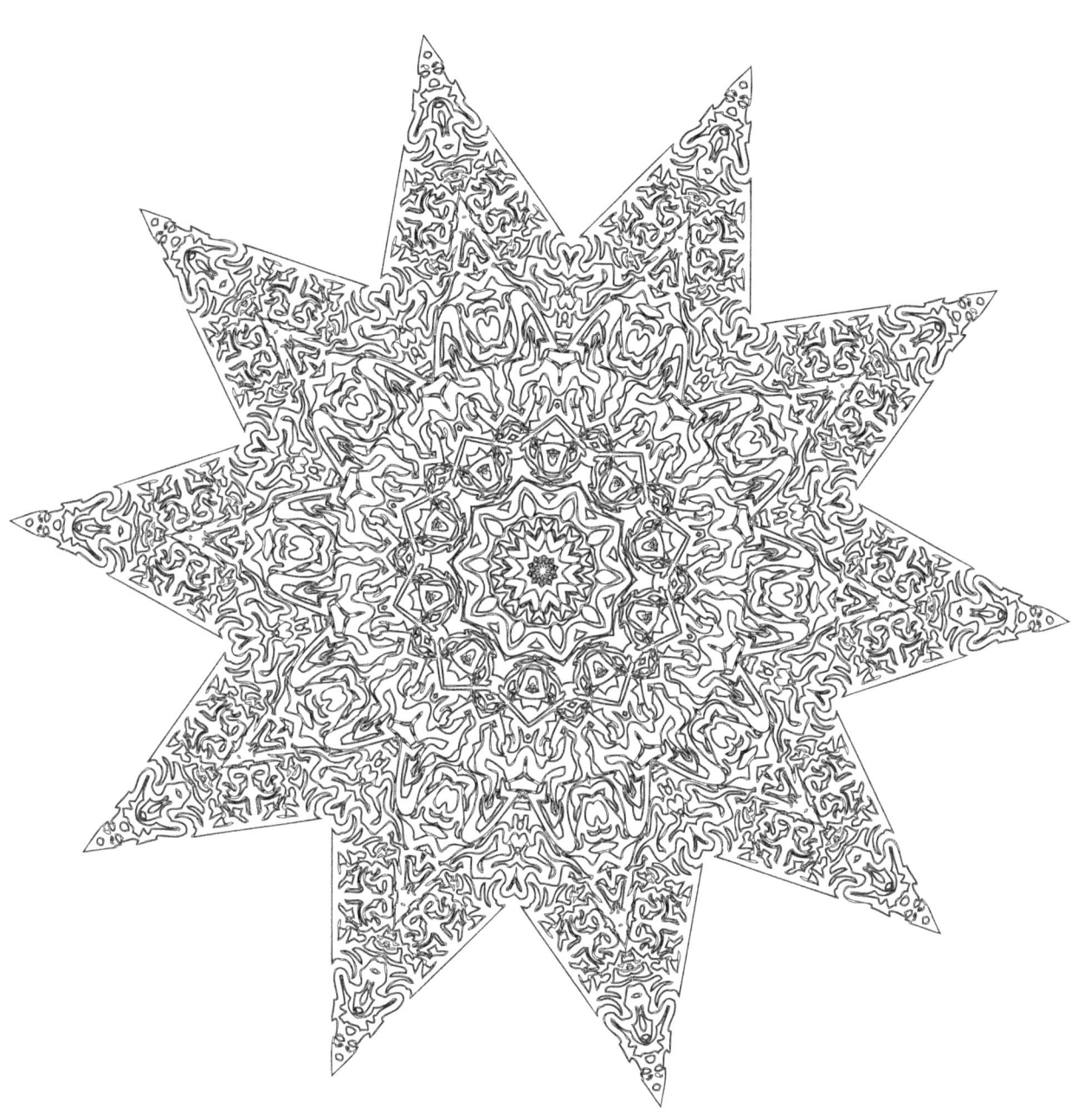

"Curiosity is the main energy..."

Robert Rauschenberg

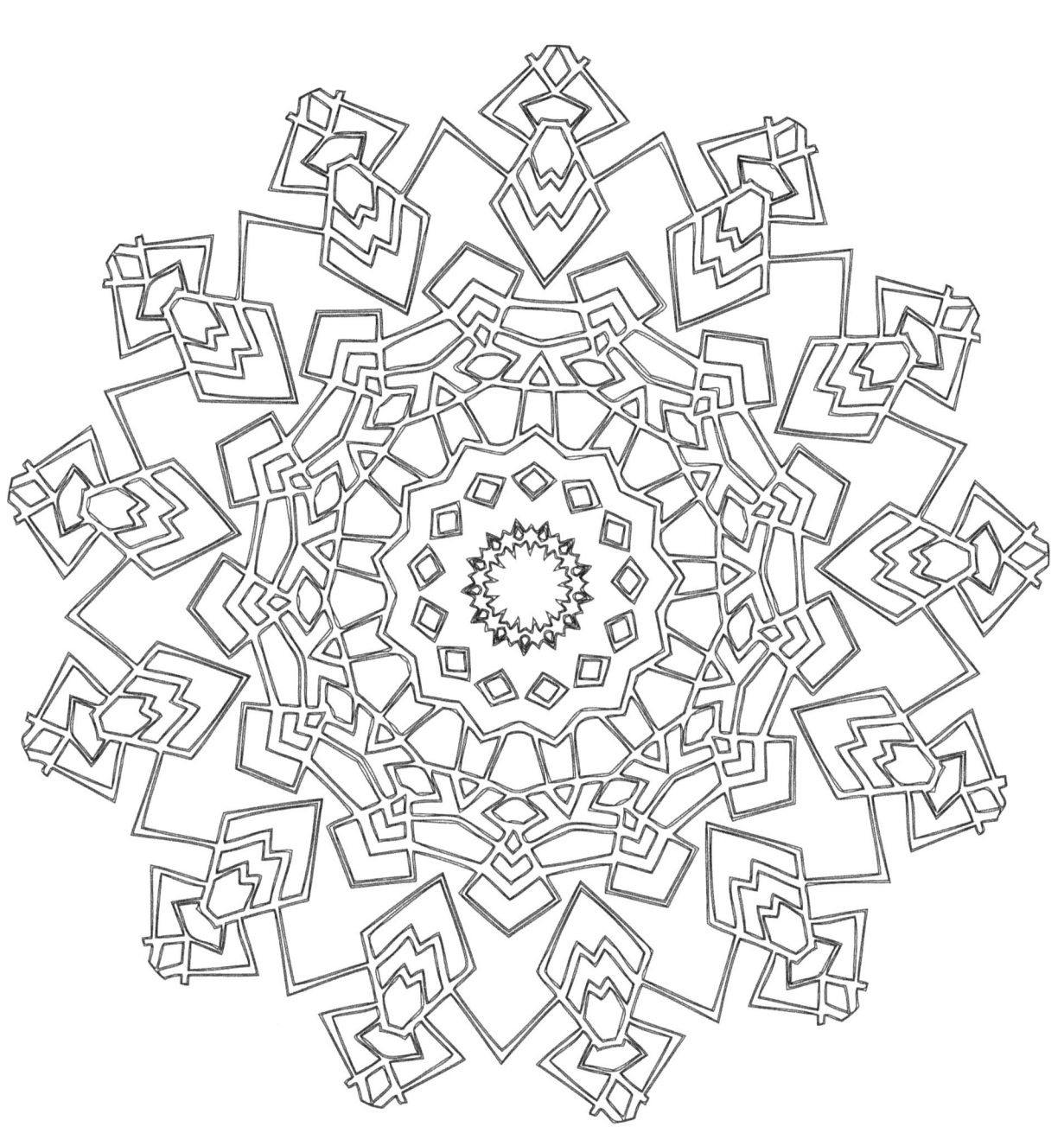

"We need our Arts to teach us how to breathe."

Ray Bradbury

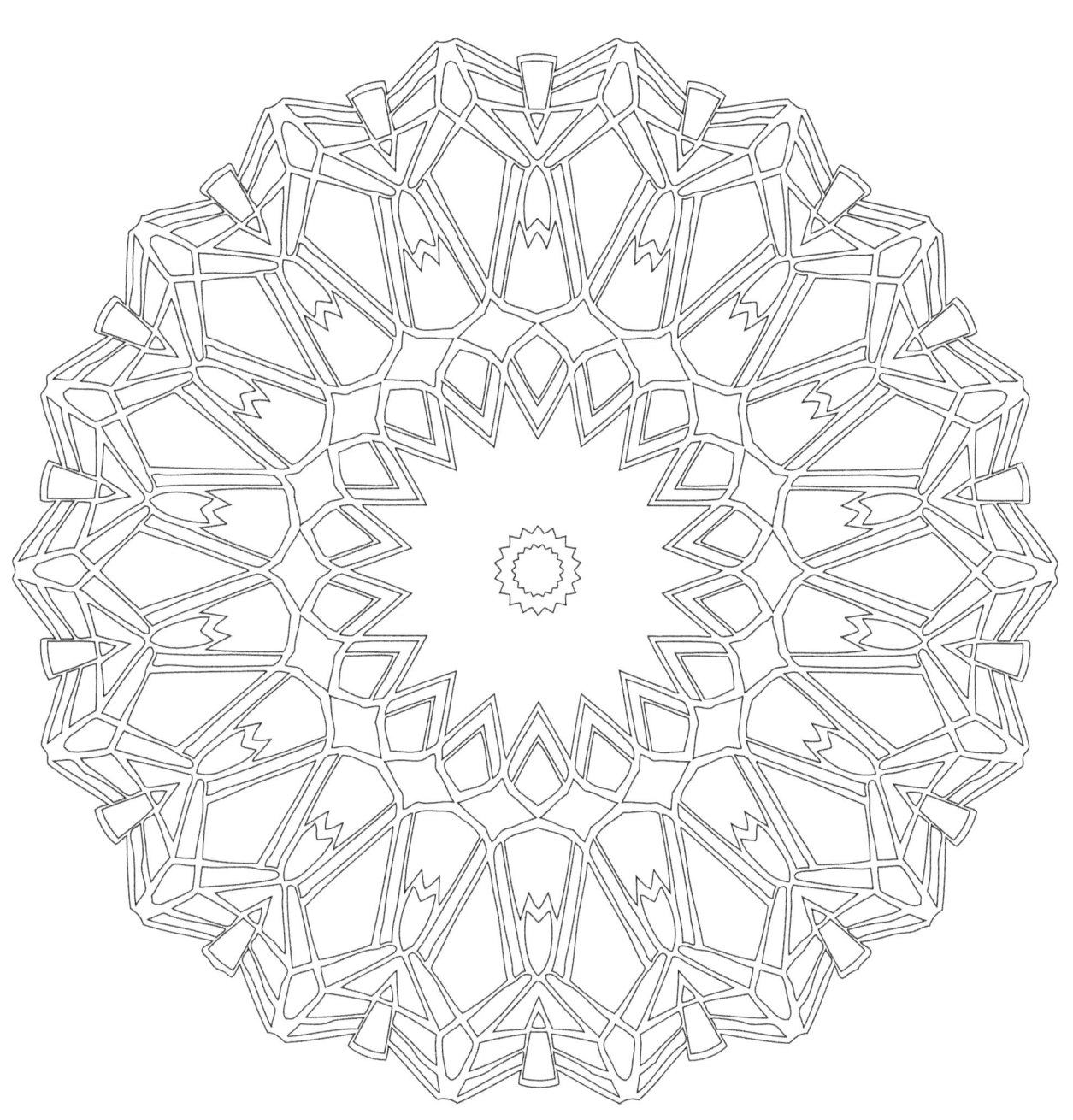

"I'm pretty much looking for beauty all the time.
It just seems like some days the light is better to see it."

Melodie Ramone

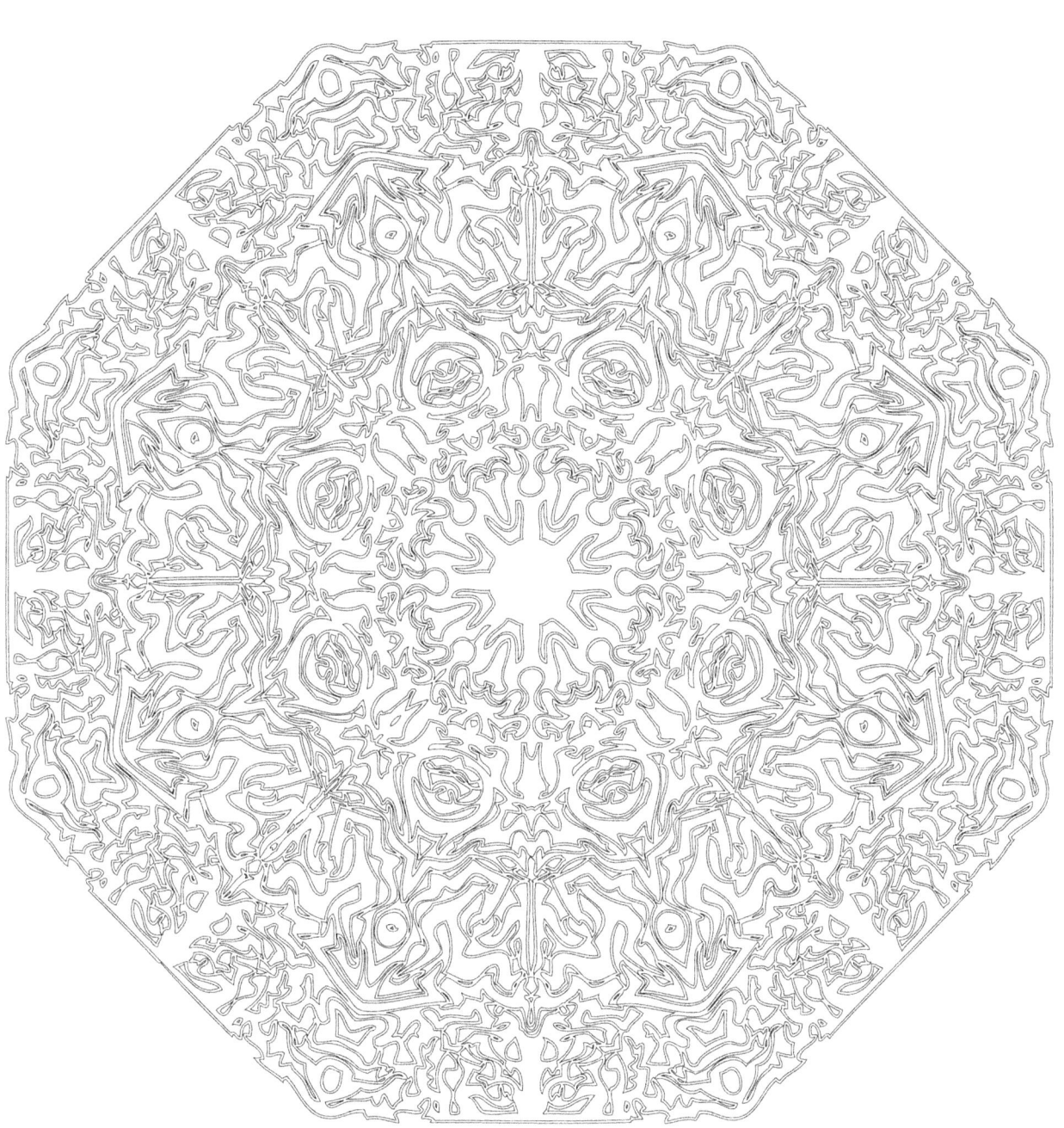

"Art is partly communication, but only partly. The rest is discovery."

William Golding

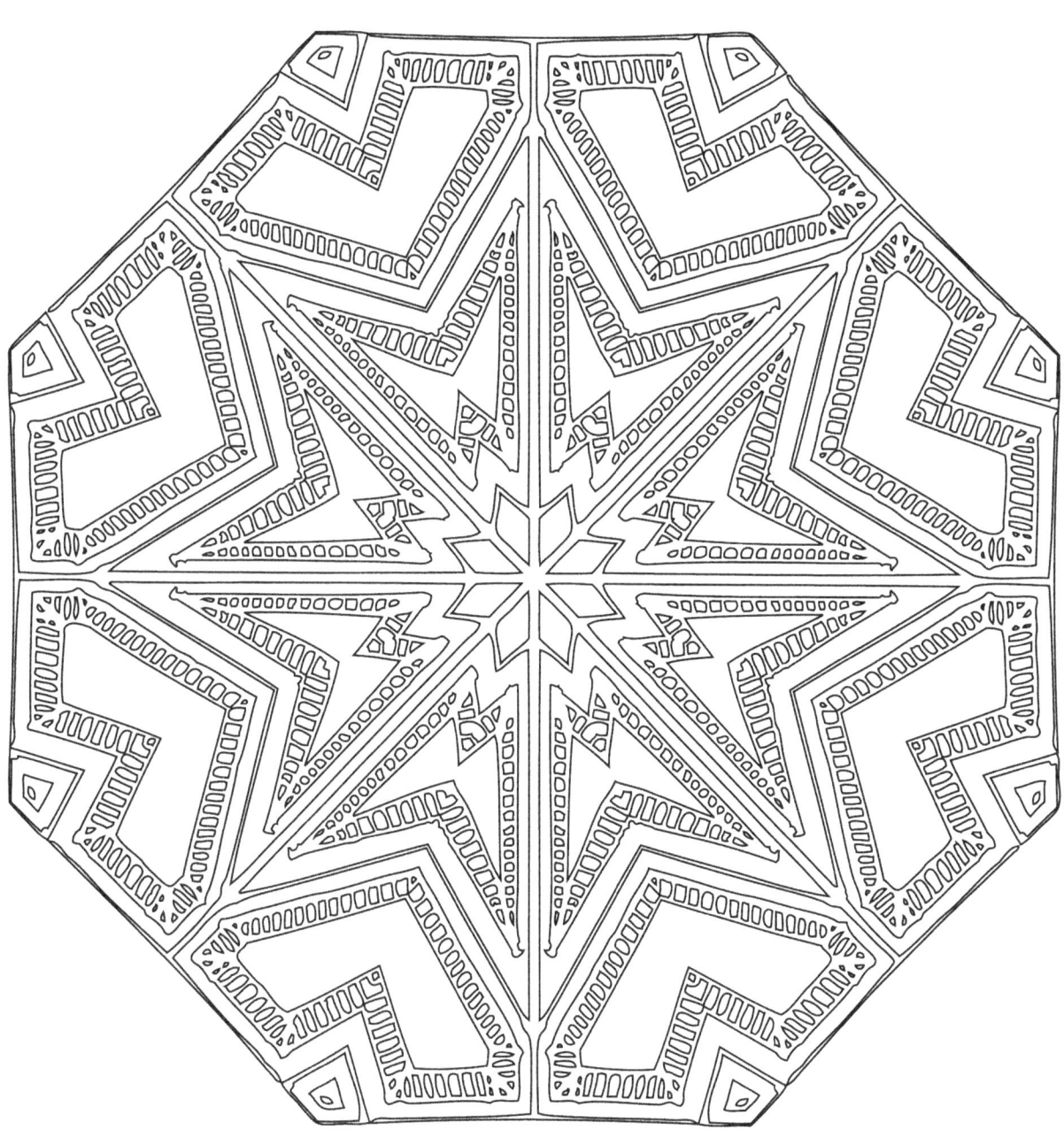

"The artist is always beginning. Any work of art which is not a beginning, an invention, a discovery is of little worth."

Ezra Pound

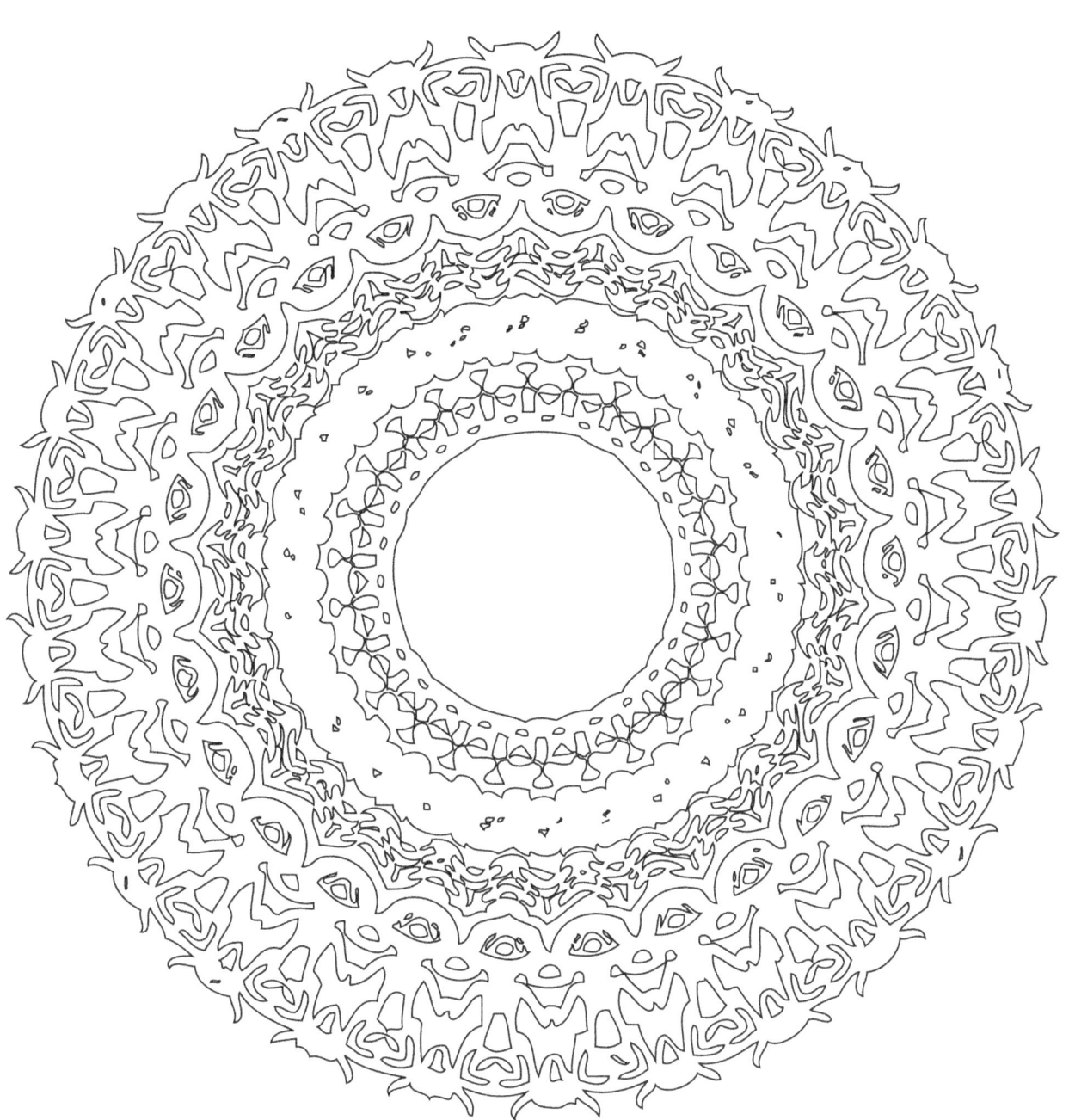

"In art there is only one thing that counts: the bit that cannot be explained."

Georges Braque

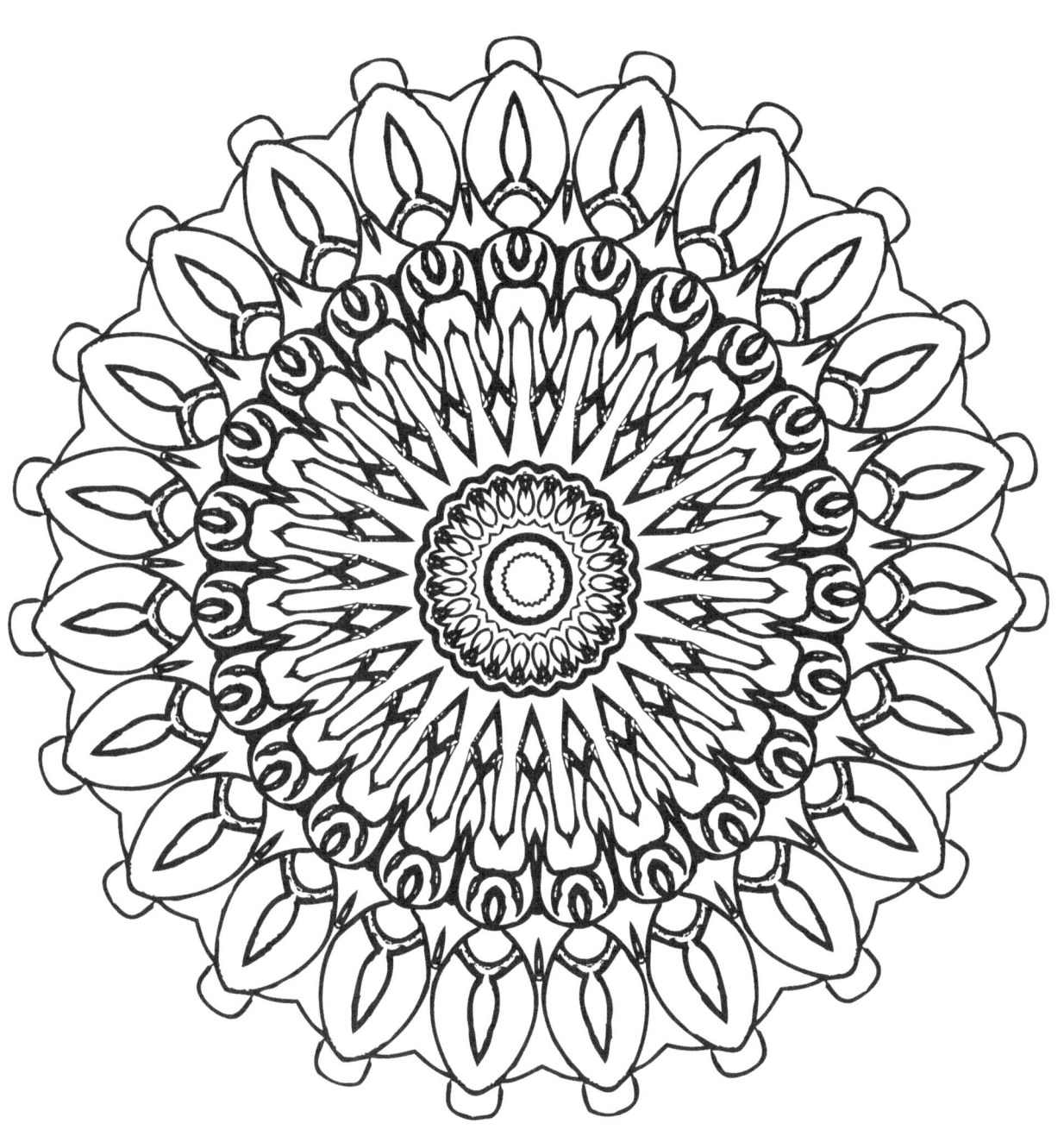

"Art is harmony parallel with nature."

Paul Cezanne

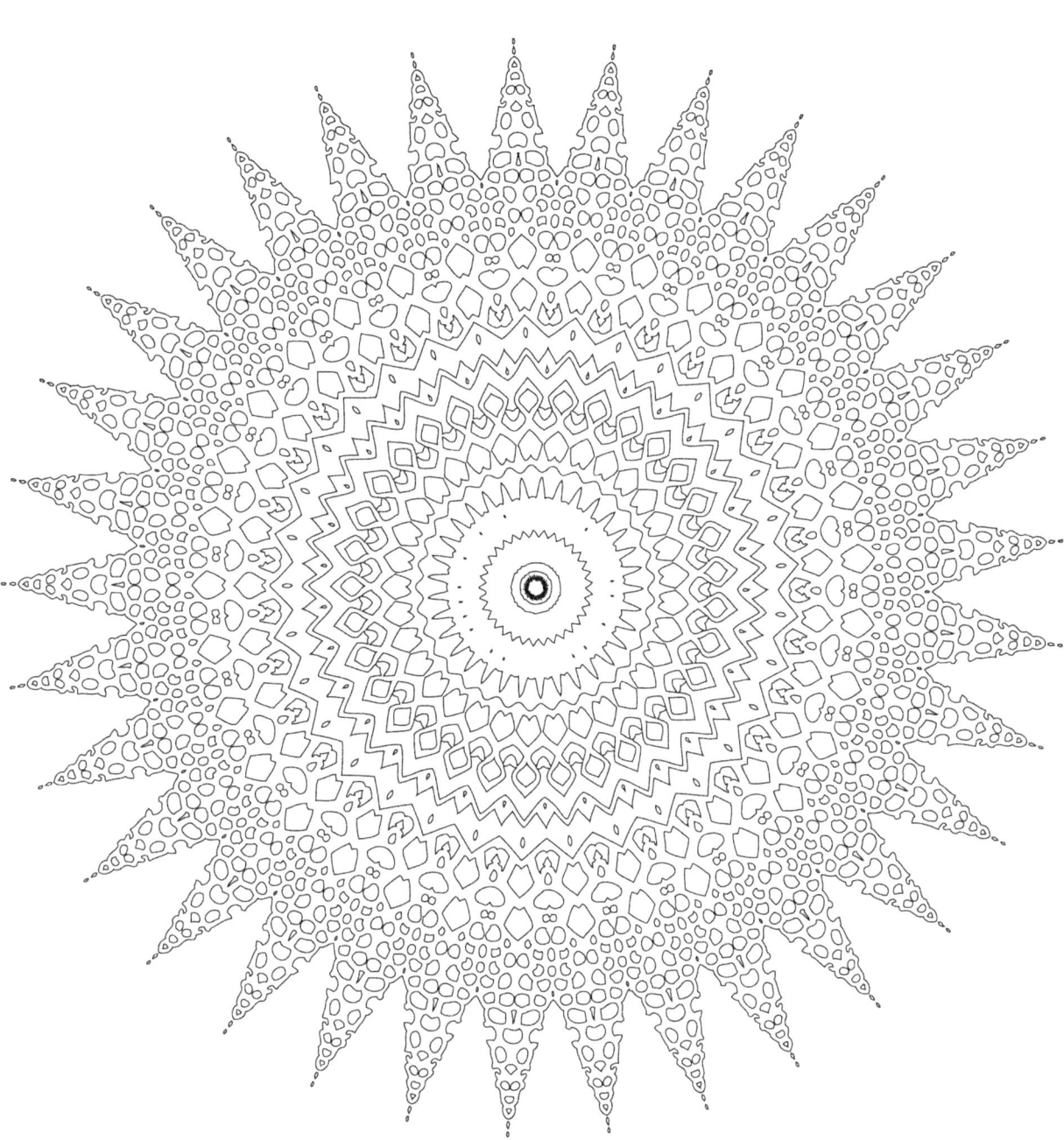

"To begin is easy, to persist is art."

German Proverb

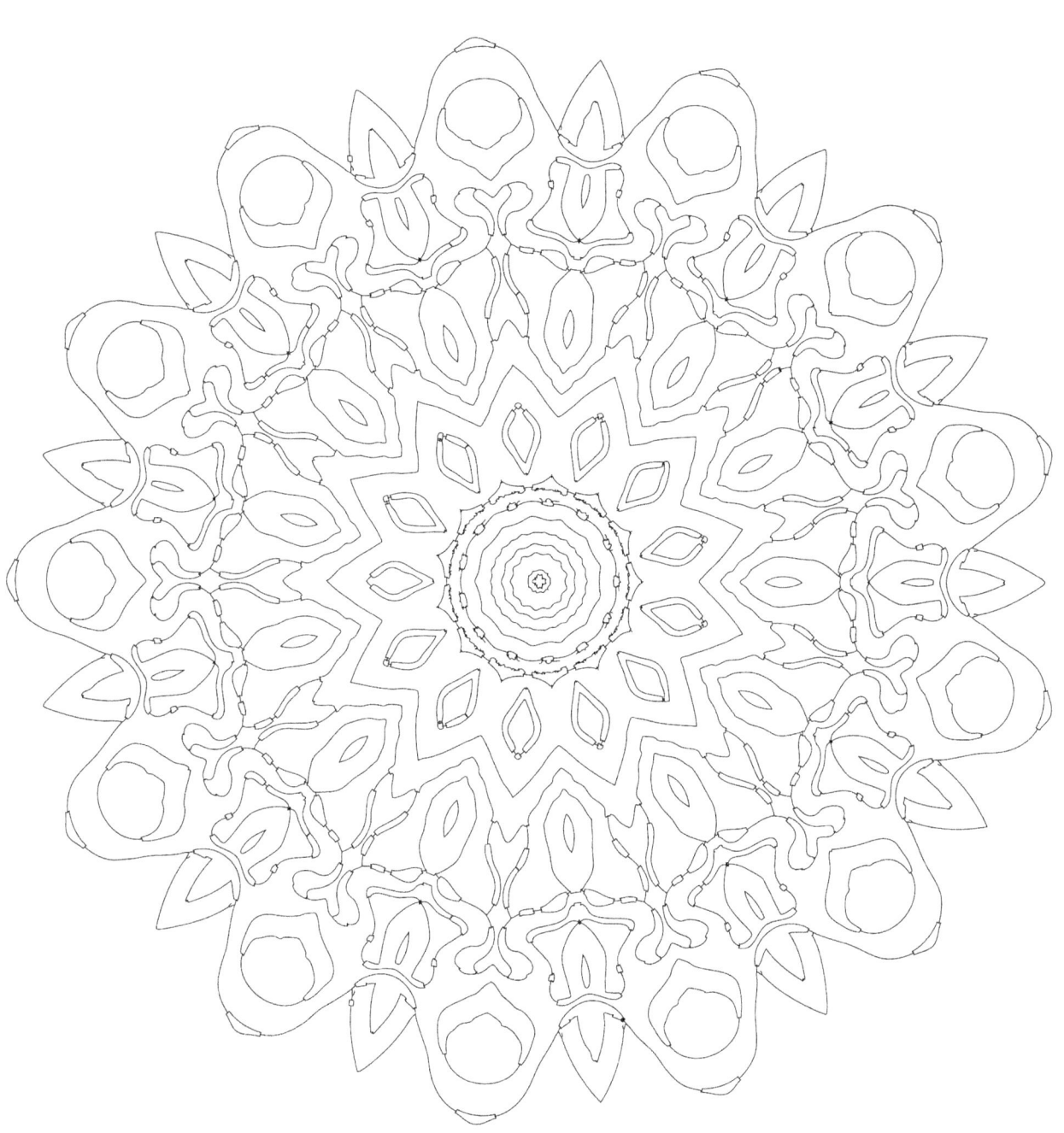

"No great artist ever sees things as they really are.
If he did, he would cease to be an artist."

Oscar Wilde

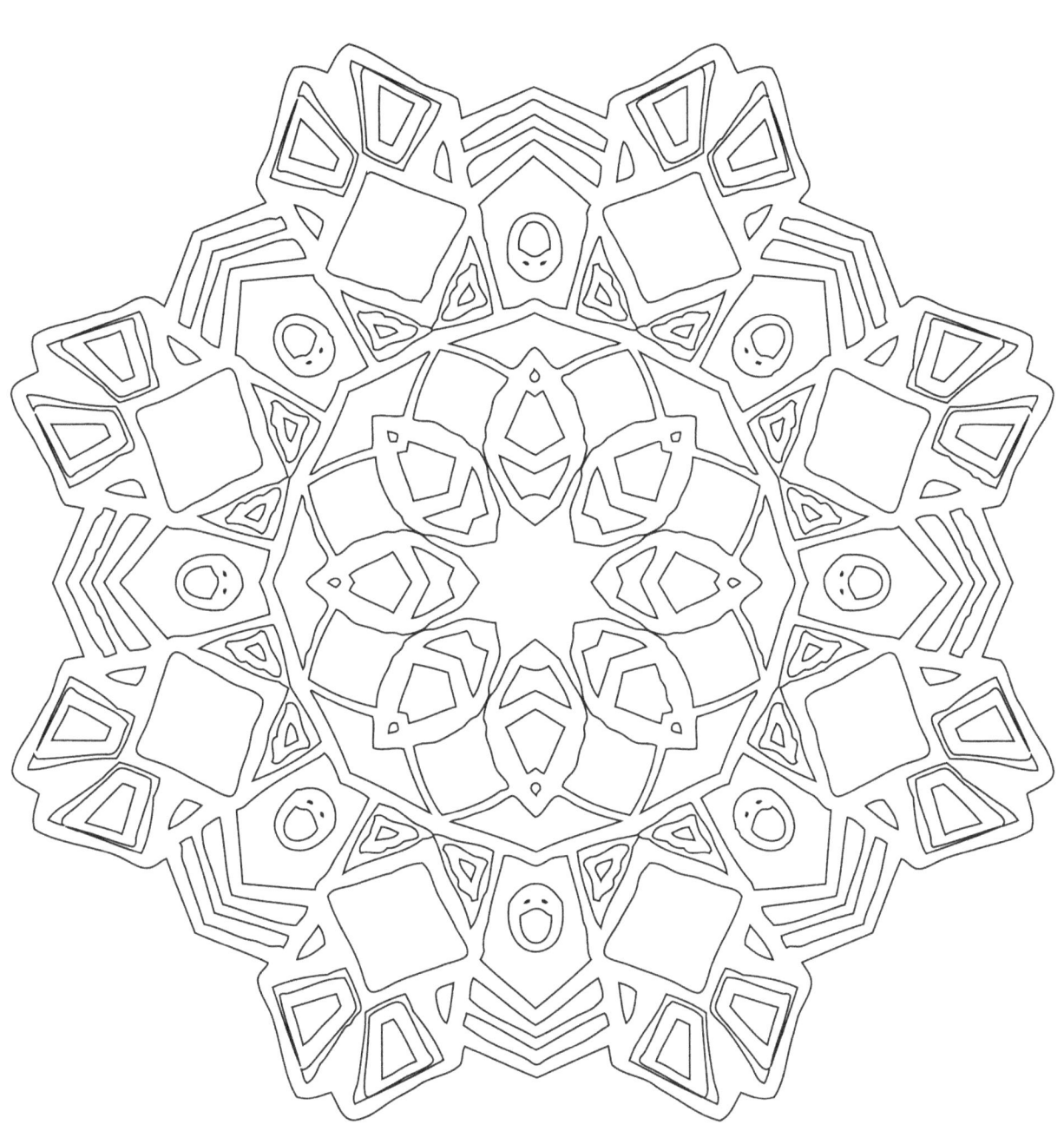

"The essence of all beautiful art, all great art is gratitude."

Friedrich Nietzsche

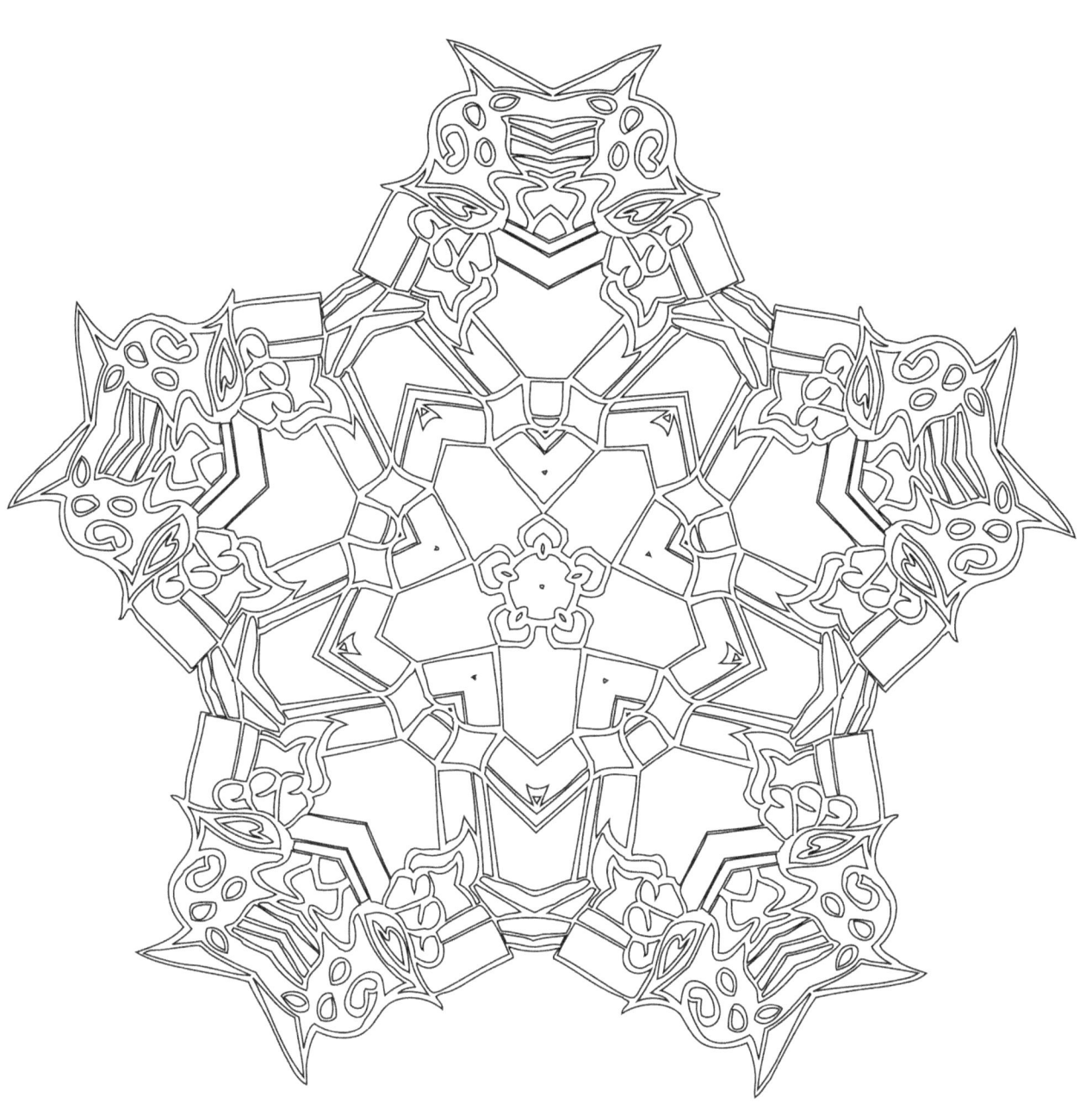

ABOUT THE ARTIST

Ken O'Toole

Ken is an experimental artist working in various media. Much of his work involves creating a "visual vocabulary" to communicate emotional or spiritual experiences and create new perceptions. Choosing the "classroom of doing," rather than more traditional training, has allowed O'Toole to accelerate his growth and remain open to experimentation.

His most recent works include paper sculptures. Combining action-painting and paper-folding techniques, O'Toole's paper sculptures display a myriad of surfaces resembling character sets and surreal landscapes.

His visionary, "Cultural Ghosts," series of black and white fine art photographs were the inspiration for the 2011 Sustaining Artists Juried Exhibit in Fort Worth.

Some notable exhibitions which included his work were:

- BJ Spoke Gallery, "PaperWorks" juried exhibit in New York, NY
- "Materiality" at the ARC Gallery in Chicago, IL
- Ann Metzger National Juried Exhibit in St. Louis, MO

In 2013 Ken O'Toole completed a public art project entitled, "Dreams at 100 Fathoms" which was commissioned by Fort Worth Public Arts for the Marine Park Family Aquatic Center.

Website: http://otoolestudio.com

Email: ken@otoolestudio.com

www.ingramcontent.com/pod-product-compliance
Lightning Source LLC
Chambersburg PA
CBHW081159180526
45170CB00006B/2150